available light
by
ken buckner

available light

PETERSEN'S PHOTO PUBLISHING GROUP

PHOTO SPECIALTY PUBLICATIONS
Brent H. Salmon/Publisher
Paul R. Farber/Editorial Director
Mike Stensvold/Editor
Gary M Schuster/Art Director

PHOTOGRAPHIC MAGAZINE
Brent H. Salmon/Publisher
Paul R. Farber/Editor
Karen Sue Geller/Managing Editor
Jim Creason/Art Director
David Brooks/Feature Editor
Joan Yarfitz/Associate Editor
Markene Kruse-Smith/Associate Editor
Mike Stensvold/Special Projects Editor
Steven I. Rosenbaum/East Coast Editor
Natalie Carroll/Administrative Assistant
Ben Helprin/Contributing Editor
Kalton C. Lahue/Contributing Editor
Steve Poster/Contributing Editor
Robert D. Routh/Contributing Editor
David Sutton/Contributing Editor
Parry C. Yob/Contributing Editor
M.A. Hadley/Far East Correspondent

PETERSEN PUBLISHING COMPANY
R.E. Petersen/Chairman of the Board
F.R. Waingrow/President
Philip E. Trimbach/V.P., Finance
Herb Metcalf/V.P., Circulation Marketing
William Porter/Director,Circulation
Jack Thompson/Assistant Director, Circulation
Spencer Nilson/Director, Administrative Services
Alan C. Hahn/Director, Market Development
James J. Krenek/Director, Purchasing
Thomas R. Beck/Director, Production
Al Isaacs/Director, Graphics
Bob D'Olivo/Director, Photography
Maria Cox/Manager, Data Processing Services

COVER
Model Connie Kreski was photographed
through screen door using existing light. Photo
by Ken Buckner. Cover design by Gary M
Schuster.

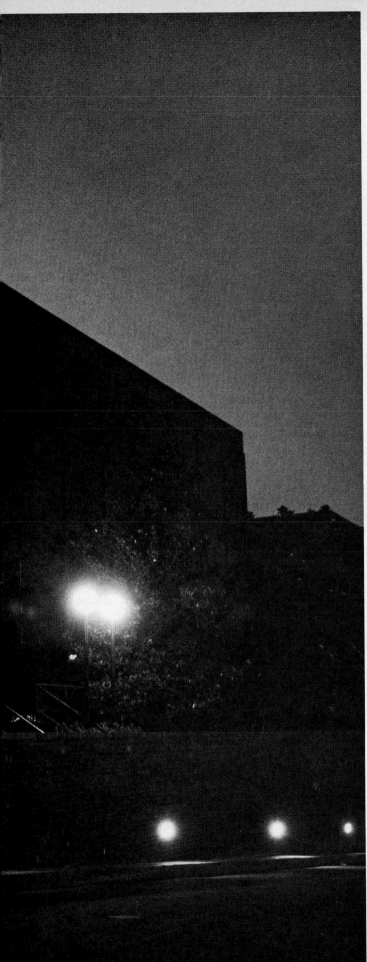

introduction

To the unenlightened, a well-equipped photographic studio is a necessity if one is to produce professional-quality photographs of such subjects as fashions, products and portrait-sitters. Really, though, all of these things can be photographed professionally by using available light in simple settings. Outdoors, the sun and the sky and the shadows provide an amazing variety of lighting effects that can be used to produce an equally amazing number of "studio" photographs. Indoors, the light coming in through a window presents a like number of wonderful possibilities.

You might not have a studio, fancy strobe units or a lot of equipment available to you, but you do have a camera, a lens and whatever light is available at your scene, and you can easily get a couple of posterboard reflectors. You'll be pleasantly surprised at what you can do with just this equipment, and a little knowledge.

One of the biggest problems encountered by new photographers is that they have no experience on which to rely in order to handle the day-to-day photographic situations that occur, the kind of experience that seasoned professionals use to produce consistently fine results regardless of the assignment.

There are two kinds of experience: your own, which you can get only by going out and shooting, and other people's—mine, for instance. In this book, I will share with you some of my experience, which should provide you with some guidelines and some shortcuts toward getting your own experience.

This book will deal with available-light photography. It will discuss much more than just low-light-level work (although it will certainly cover this topic at length), because the working photographer will encounter many kinds of available-light situations. I'm going to tell and show you how I handled a great many of these situations, and how you can do the same—produce professional-looking results without a studio or artificial light sources.

This book will show and tell you how to make the most of what is available to you at the scene of your photograph—how to deal with the light as you find it, and how to use this light to produce the effect you want. In short, the book will show you how to do what I do. You can go through it, and then use the information as a basis for your own experiments in photography in order to acquire your own experience, an exercise during which you can develop a personal style that will set your work apart from everyone else's.

Before getting into how to use available light for various photographic situations, I'd like to give you a few words of wisdom gleaned from my years as a photographer, words that might make your years as a photographer go a little easier.

First, most people who look at a photograph don't care what you went through (or didn't go through) to make it. They see what is there. If it looks good, if it looks right, then it *is*, whether it was made in a lavishly equipped studio or in your backyard.

Second, you'll always find someone who loves your work, and someone who hates it. Be ready for this, and it won't hurt so much.

Third, your personality, enthusiasm and attitude are as important as your photographic skills, especially when you are dealing with people.

Fourth, when you take pictures, take them with much care and planning, as if your reputation depended on it. It does. It's before you take the picture that you have all the time in the world to plan exactly what you want on your film.

Fifth, anyone can take a good picture. What separates the good photographer from anyone is the ability to take good pictures consistently. The ability to do this comes from thought, practice and desire. Don't just click off frames of film. Think. Plan. Do your best, and your best will show in your photographs.

Sixth, never be afraid of sharing your ideas and techniques with fellow photographers. After all, it was fellow photographers who inspired and taught you.

I'd like to thank the following people for my inspirations:

James W. Lennon, my late step-father, for paying the bills while I was a "struggling artist."

Herbert Boggie, photography instructor, for showing me it's what's six inches behind the camera that counts.

Patrick Osso, photographer, for teaching me about the business of photography.

Dan Rowan, comedian, for showing me a quiet form of class, and for a job when I needed one.

Arte Johnson, comedian, for teaching me the beauty of patience.

Mario Casilli, photographer, for a lot of my inspiration and the fact that I am in Los Angeles instead of Florida.

And the hundreds of nameless photographers who love their work, and inspired us all.

And last but not least, Betty and Sam Jaffe, for showing me the beauty of true love. □

outdoor fashion

There are, if you consider it, six basic lighting situations that you can use without resorting to reflectors or auxiliary lighting: direct sunlight, controlled shadow, heavy overcast, backlit sun, open shade and reflected shade.

DIRECT SUNLIGHT

The biggest problem with direct sunlight is too much contrast. I don't know why, but many photographers, in the studio with a strobe, will position the light to light the model's face in an attractive pattern, yet outside the studio will use the sun no matter what position it's in. If it's high noon, and the model has harsh shadows and enough contrast to make her look like a reject from a late-night horror movie, they'll still shoot.

You can move the model to achieve better lighting, or you can "move the sun"—pick the proper time of day to get the lighting you want. The accompanying example of a direct sunlight photo was taken with the sun about 10 degrees above the horizon. As you can see in her glasses, the sun was just above the tree line and therefore could easily be used with the model looking directly at it. If you happen to be out shooting and there is a thin overcast, consider this a blessing from heaven, because the model will be able to look in the direction of the sun at almost anytime and the shadows will be a little softer than the ones in the example.

Without an overcast, the basic problem of too much contrast is handled by a general overexposure and underdevelopment of the negative. The amount of overexposure and underdevelopment is best determined by experience, but any attempt will be beneficial to the quality of your negative. The purpose

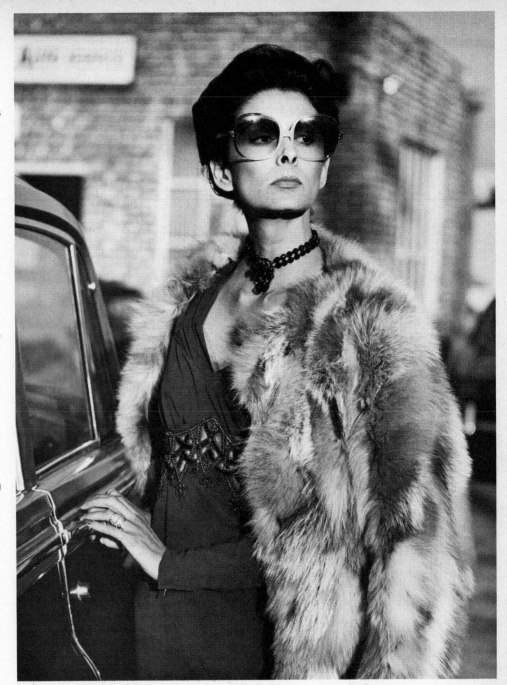

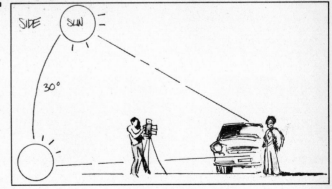

When working with direct sun, the secret is to use it as you would a single studio light, and develop the film less to lower the contrast. Best direct-sun results are obtained when the sun is within 30 degrees of the horizon, and within 30 degrees either side of the camera as well. Model is Ann-Marie.

of the underdevelopment is to stop the development of the highlight areas; the purpose of the overexposure is to assure sufficient detail in the shadow areas of the scene.

If you intend to work with direct sunlight, try to keep the sun within 30 degrees of either side of the camera, and no higher than 40 degrees above the horizon. This means shooting in the early morning or late afternoon. As mentioned before, direct noon sunlight, coming from such a high angle, produces harsh shadows and poor portraits.

CONTROLLED SHADOW

Here, a building is used to stop the light from reaching the model; therefore, her face is lit by light from open sky on the side opposite the building. A slight backlight effect in the example photo is produced by light that has spilled around the corner of the building, appearing as slight highlights on top of the model's hat.

With this type of setup, you can adjust the amount of facial contrast by moving the model closer to or farther from the building. You can also adjust the

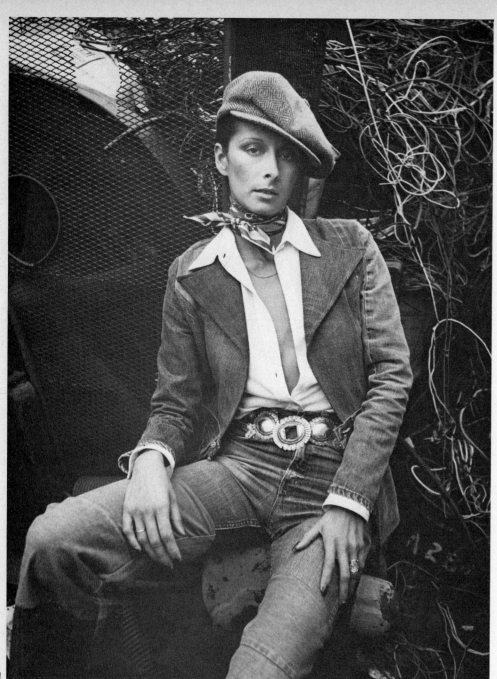

1. If you have open sky as the light source and want to create a lighting pattern on your subject, you can do this by shooting near a building and using it to stop the light. Model is Ann-Marie.

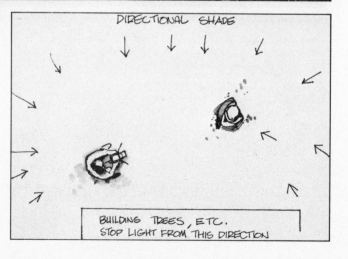

DIRECTIONAL SHADE

BUILDING TREES, ETC.
STOP LIGHT FROM THIS DIRECTION

backlight effect by moving her closer to or farther away from the corner of the building.

This type of lighting generally produces a lack of density and contrast on the negative, which can be corrected by slight overexposure (about ⅓ of an f-stop) and overdevelopment (about 10-25 percent more than normal).

HEAVY OVERCAST

A heavy overcast produces a 1:1 lighting ratio—the shadow and highlight areas receive the same amount of illumination. This kind of situation is best handled by exposing the film normally, but overdeveloping it about 50 percent. Overdeveloping forces the highlights to continue developing while the shadows do not.

BACKLIT SUN

This type of lighting combines direct sun with shadow lighting. Here, the sun is behind the model. The best advice I can give for backlighting is to shoot when the sun is low in the sky, so that you get a rimlit effect (a kind of halo around the model's head) instead of just a glaring white background.

When you take your meter reading, make sure that none of the sunlight is hitting your meter, because you want to expose for the model's face, which is not lit by any sunlight. The film should be developed for about 25 percent longer than normal, to restore contrast.

OPEN SHADE

Open shade is a variation on the overcast and controlled shadow lighting patterns. In the example, the building behind the model is blocking the sun, and she is facing into open shade. This type of lighting is excellent when you want a '40s-type look, with a gentle unidirectional lighting pattern. This will give you a

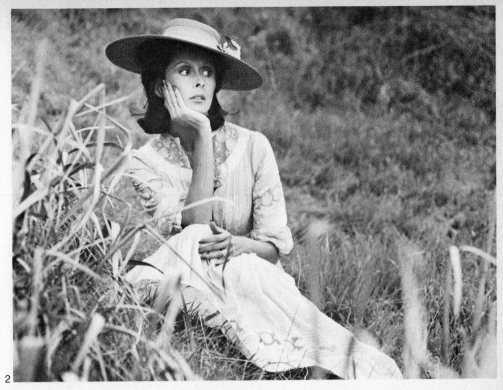

2

slight problem with contrast, since you are using the controlled shadow technique, but the direction of the light gives you no subject contrast to speak of. Therefore, you must develop the film and expose as you would for controlled shadow. In the example shot, I overexposed the film to assure sufficient density, and developed it normally so that the lack of contrast would give me a gentler '40s look.

By now you may have discovered a rule of thumb for all black-and-white photographs: Exposure of the negative controls its density, and development controls the contrast of the negative. Experimenting with

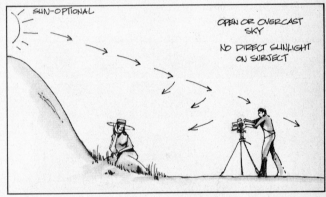

these variables, using my recommendations as guidelines, will give you the control needed to handle any photographic situation you might encounter.

REFLECTED SHADE

The last example shown was taken while working with the model on an open street. I did achieve a direction of light by using the buildings on the opposite side of the street as a gigantic reflector. Here the lighting is soft but

2. If you are shooting on an overcast day, the problem is not the lighting, but the flatness of the resulting negative. This is taken care of by overdeveloping the negative to force the whites and blacks into the proper relationship. Model is Ann-Marie.

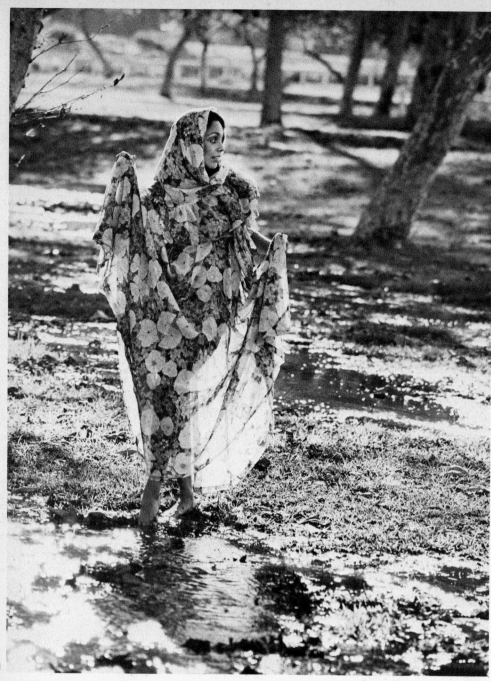

directional as well. The problem again is lack of contrast, and this can be corrected by slight overdevelopment.

This kind of lighting is perfect when the sun is high (if you must shoot at noon, try this lighting), with the side of the street you are working on in shadow and the other side in sunlight. I am not going to say that you are going to walk down the street and find a bunch of white buildings on one side of the street and beautiful backgrounds on the other. You are going to have to look, and when you find a street that comes close to this ideal, file it away in your memory and use it when you want this kind of lighting.

A FINAL TIP

You should use at least one full roll of film on each particular subject you shoot for your outdoor portraits. If you don't shoot at least 12 shots of a given subject using 120 film, or at least 20 shots if using 35mm, then you are not covering the subject well enough. Each picture in this chapter was taken on 220 film, and in each case I used all 24 exposures to get the shot I wanted, giving each frame minor variations. The one exception was the last shot, which was one of 36 exposures made of the model on a roll of 35mm film—any time you have motion in a fashion assignment, you are going to encounter problems such as wrinkled or bunched clothes, so it's a good idea to shoot a lot of frames. Remember, the cheapest thing you have to work with in photography is your film. □

1

1. A good negative is produced in a backlighting situation by exposing and developing for the shadow area, without considering the sunlit area. Model is Mary Ann Madrid.

SUN LIGHT

SHADOW

LOW SUN FOR LESS REFLECTION OR BURN-UP ON HAIR & SHOULDERS

METER ONLY OPEN SKY SHADOW AREA.

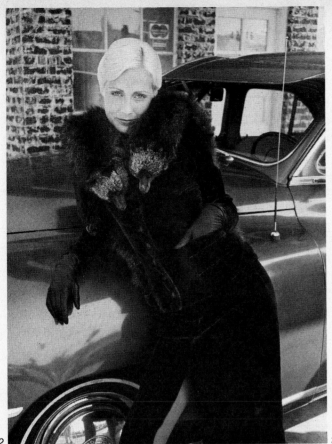

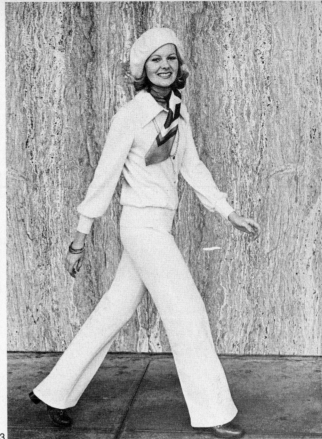

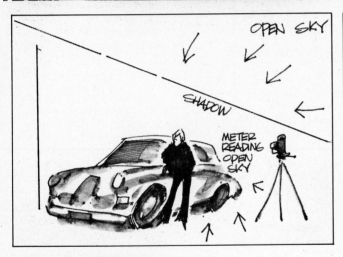

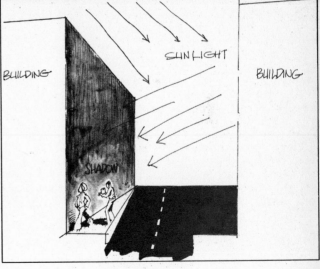

2. Soft, almost flat lighting is perfect for '40s style of photography. With slight overexposure and overdevelopment, the negative will be very workable for printing. Model is Ginny Kaneen.

3. The low-light areas of a shadowed street scene are lit up by using the buildings on the opposite side of the street as huge reflectors. Model is Kari Crosby

outdoor illustration

Products are probably the easiest of all photographic subjects to take good pictures of, but also the hardest to take a great picture of. Products don't move, they don't blink, and they don't complain. You can take your time and choose your f-stop, shutter speed, lighting position, camera angle and everything else with them.

A couple of reflectors and the sun are all you need to do any product photograph. I have chosen six lighting techniques to show you here, although there are many more. Included are shots showing the setups, as well as the final results. These words and pictures should prepare you to handle a tremendous variety of product illustration situations.

DIRECT SUN AND REFLECTOR

This technique simply involves using direct sunlight and a main light source, and using a white cardboard reflector to reflect some of the sunlight into the shadow side of the product, to reduce the contrast. The closer the reflector, the less the contrast; the farther away the reflector, the greater the contrast will be. In the example photo, the use of the reflector helped to emphasize the round shape and contour of the bottle, and kept it from merging into the background, as well as providing fill lighting on the shadow areas.

BACKLIT SUN AND REFLECTOR

Backlighting, with the sun as a backlight behind the product, and a reflector bouncing some of the sunlight back into the product, can produce striking results. When using this lighting, watch out for shiny products, which can reflect the sun into your lens. If you want to tone down the amount of reflection from the product, you can use a nonpermanent dulling spray. You will also find it helpful to keep the sun fairly high. If the sun is too low, it will produce a glaring white background that will divert attention away from the product itself. In the example, the reflector is once again used to show the roundness of the bottle, as well as to reflect some light into the shadow area.

OVERCAST AND REFLECTORS

With an overcast, you have no direction of lighting or excessive contrast problems, and this is an ideal situation in which to work. If you want to create a direction of light, you can do so by using a black reflector along with a white one. In our example, the black reflector was used to stop light from above the product, while the white reflector was used to kick extra light into the front of the subject. This produces a very gentle direction of lighting.

If you want this gentle light, and the sun is out, you can use this same technique, as long as you don't show very much background in the frame. This gentle lighting will usually force you to overdevelop the film slightly to gain a bit of contrast.

DIRECT LOW SUN

Using the sun when it is very low in the sky—at sunrise or sunset—is a fourth product lighting method. With the sun very low in the sky and placed over your shoulder, you'll have considerable light fall-off on the edges of your products. You can add the effect of texture if you move so that the sun is slightly to the side of your product. You can also use reflectors on both sides of the product, out of

camera range, as shown in the example, but watch out for lens flare caused by too much reflection.

TENT LIGHTING

If you have very reflective products, which will show distracting reflections of light sources and the camera, the answer is a light tent. This can be made from a bed sheet placed over a couple of light stands, as shown in the example. The lighting direction is controlled by placing a black cloth over the side or top of the tent to achieve any number of lighting angles. If you want nothing but front lighting, have the light coming from the direction of your camera and simply cover the top of the tent with the black cloth. However, keep the white sheet on the inside of the tent, so that the reflection on your product is cut to a minimum. The light tent is also excellent for a setup where no direction of lighting is wanted.

GRADATED BACKGROUND

The gradated background can be produced in varying degrees by placing the product on a white seamless background and using a black reflector to stop light from reaching all of the background. The white seamless background serves as a reflector as well as a background. A thin translucent reflector can be used to soften (diffuse) the sunlight falling on the subject. With all these reflectors in use, watch out for reflections on the product that you don't want. This is an effective setup, but rather time consuming, so plan to be ready before the sun gets near where you will want it.

Starting with these six techniques, you should be able to switch this, change that, and come up with at least 60 variations on the same theme. □

3

4

1-2. Product was photographed using direct sunlight and one reflector to emphasize contours and control contrast. Double exposure shows size and position of reflector.
3-4. Here, the sun was behind the product as a backlight, and a reflector was used to light the front of the bottle.

1

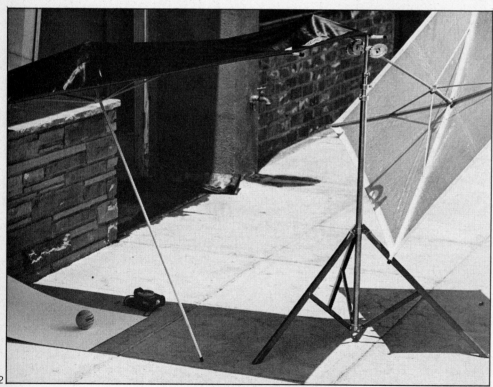

2

3

4

1-2. Here lighting direction is provided by using black reflector to stop light from above, and white reflector to direct light onto subject. Result is very soft, gentle direction.

3. Low, direct sunlight without a reflector produces harsh shadow and gradation.

4-5. With reflector positioned as shown, dark side of ball and shadow show more detail, but lighting still shows roundness of the ball.

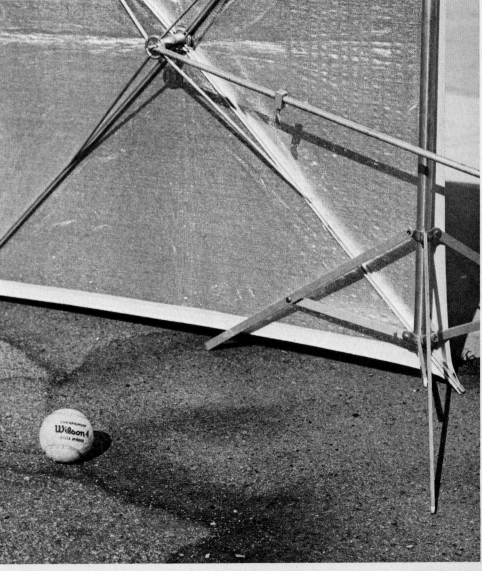

5

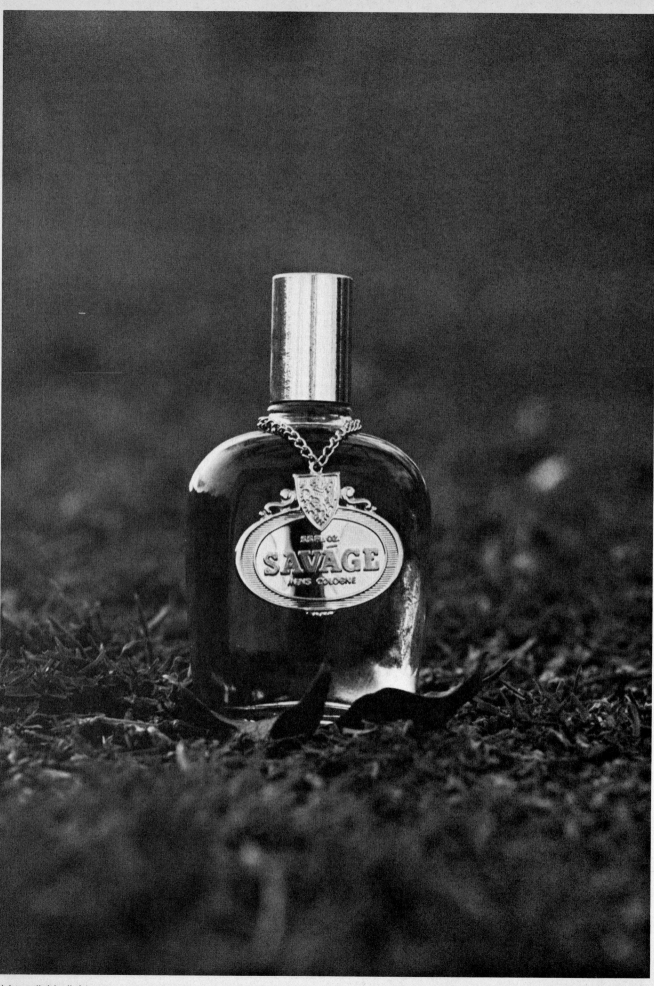

2

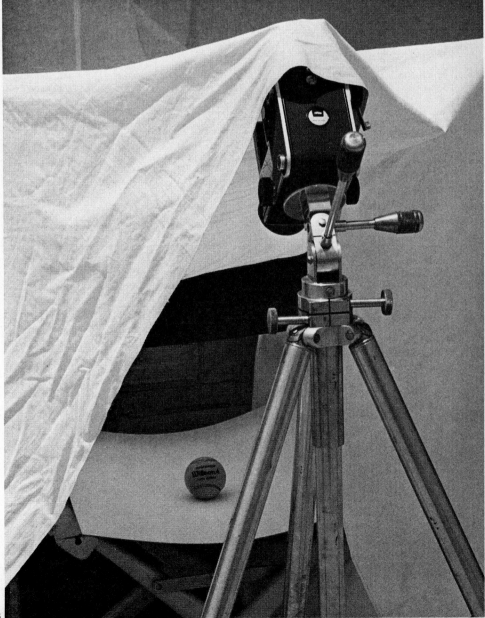

1. This is same technique as the other low direct sun shot, but here sun is in rear, and two reflectors (which can be seen reflected in label) are used to light front of bottle.
2-3. Light tent produces soft, low-contrast, almost shadowless lighting, which is perfect for very reflective objects.

3

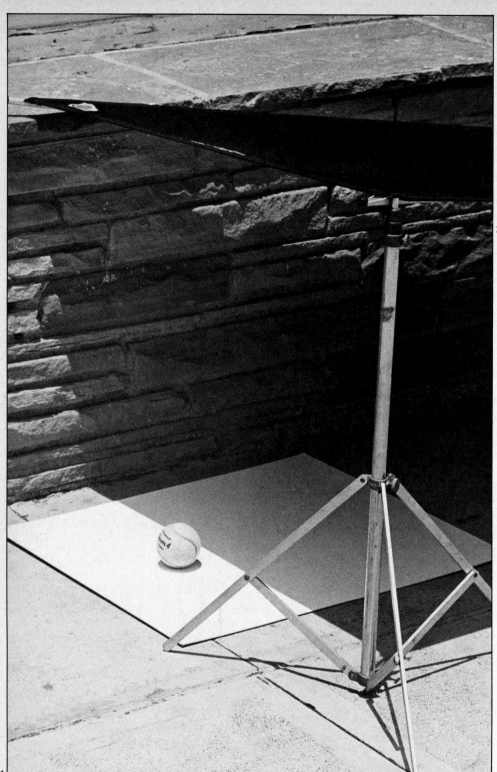

1-4. Gradation effect is produced in varying degrees by use of different types of scrims. Dark reflector placed close to product (1 and 2) produces sharp, harsh effect; edge of roof, farther from product (3 and 4) produces softer effect.

3

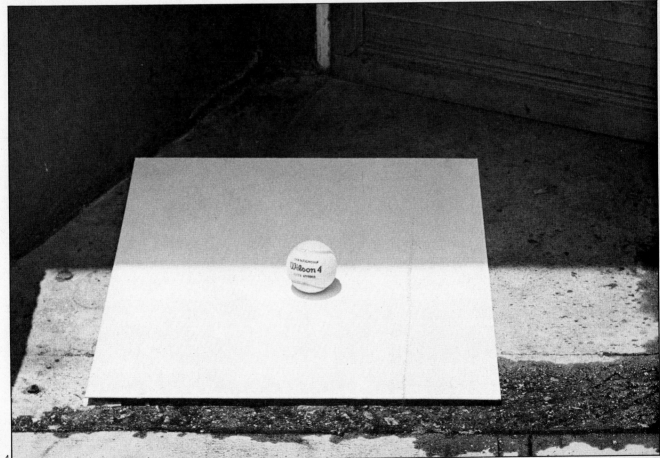

4

indoor illustration

Indoor illustration photos usually look like they were quite complicated to produce, but actually they are quite simple, once you know how.

The pantyhose picture is the result of printing two negatives on one sheet of paper. The two shots were taken in very flat (nondirectional) lighting, so that the white background would show no shadow. I took a meter reading from the white background, and exposed so that it would be reproduced as white, which involved opening the lens up three stops from the meter reading. (Reflected light meters give readings that will produce whatever they are pointed at as a middle gray tone. White is three stops brighter than a middle gray tone.) By exposing for the white background and developing the film normally and adding the contrast when making the print, I was able to accentuate the roundness of the leg, with no loss of detail. In the darkroom, I printed the two negatives, one at a time, with enough contrast to keep the background white. The end result turned out to be one of the most popular pictures in my portfolio.

The picture of the violin and rose is included in this chapter as an example of a product illustration angle that looks normal but isn't. If you anchor the product to the background, you can position it any which way to give you the lighting direction you want. One exception to this is clear bottles of liquid—if these are not oriented properly, the liquid contained in them will show it. In the example photo, I used Kodak white spotting color and painted the edges of the rose petals to give them an extra touch of life.

The tennis ball shot was equally simple. I used one window and two pieces of background paper. I pinned the edge of the dark background paper just below the edge of the window and out of the picture area, and ran it out far enough to keep it out of focus and to get a slight rimlighting from the window itself. It was extended until it was out of the bottom of the picture. Then I ran the white seamless background material from the black material to the front of the camera, and checked the background for even lighting. I then overexposed the negative about 1/3 f-stop and overdeveloped it about 20 percent, to give it adequate density and contrast with the soft backlighting.

In the next example, I placed the product (a bottle) at an angle to the window providing the light, to show the roundness of the bottle. I had a lot of light fall-off on the unlit side of the bottle, so I used a large reflector to bounce some light onto it and give that side of the bottle some roundness and contouring. Again, the gentle sidelighting makes it necessary to overexpose and overdevelop the negative slightly. The background was darkened here by using a black reflector at an angle to stop the window light from hitting the background. This provided a very soft and hardly perceptible gradation of the background.

For the shoe shot, I showed the floor of the

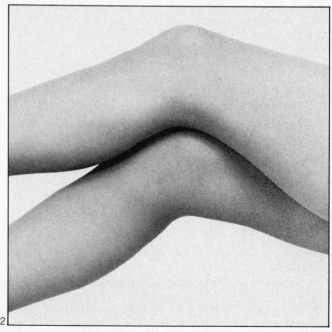

1

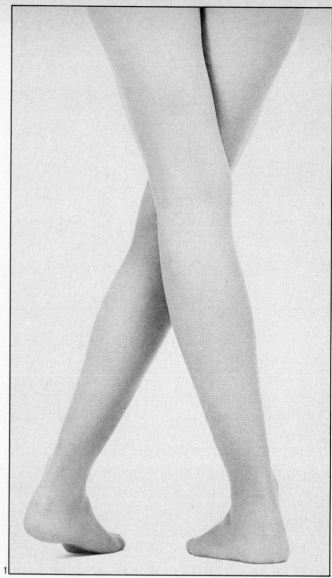

2

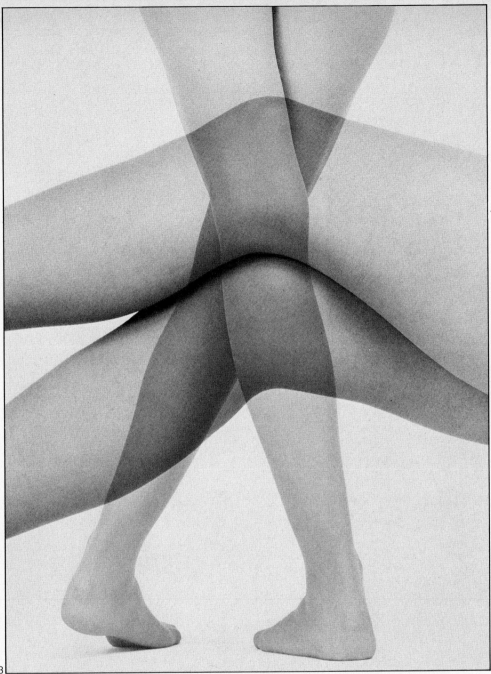

4

1-3. Two negatives of model's legs were printed on one sheet of paper to produce final print.
4. Violin and rose are actually angled downhill and on side to obtain desired direction of lighting from window.

seamless background so there would be a shadow under the shoes. This does not always work, however, and sometimes having the model sit down and lift her feet will look better. To increase the gradation, I positioned the model slightly off the direct angle to the light and had her hold a large black scrim to stop the light from hitting the background. This provides the gradation that is quite popular in today's technique, and also gave very soft, almost nondirectional lighting. To add some life to the shoes, I positioned them at an angle to reflect some of the light coming from the window, and slightly overexposed and overdeveloped the film to improve the density and contrast. Even after this was done, I added a little contrast in the printing to get the floor whiter and make the gradation a little more obvious.

The jewelry shots were made using the same basic setup, except a white reflector was used to "kick" light onto the subject, instead of the black reflector to keep light off the subject. The reflectors were placed on the side away from the light (window), and positioned to not only reflect light into the jewelry, but to be reflected in the jewelry as well. This gives the very reflective jewelry something to reflect that is simple and has very little detail, which helps to show the detail in the jewelry itself. Otherwise, the surface will simply reflect the darkened room away from the window.

The last shot is the standard "pattern with a center of interest" picture. Here I took a Porsche patch and sewed it onto the shoulder of my partner's white sweater. He stood in a doorway and I used a reflector to control the contrast. The fact that I was using a white sweater prevented me from overdeveloping, because of the possibility of blocking up the white on the negative, so I had to print for the contrast to keep from losing the fine texture of the sweater.

As you can see from these examples and how they were done, it's the final result that counts, no matter how it was produced. And it's not hard to produce professional-looking final results with simple setups. □

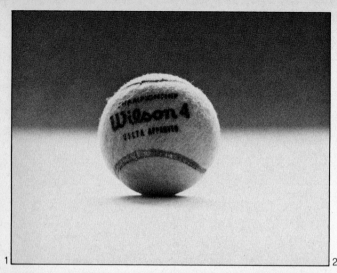

1

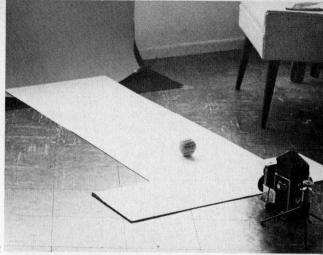

2

3

4

1-2. This setup was used to
provide gradated background for
tennis ball shot.
3-4. Reflectors were used as
shown to control fill and fall-off
of light. Bottles containing liquid
should always be photographed
in upright position if liquid is
visible.
5. Gradated background was
produced in shoe shot by having
model hold black reflector to
keep light from hitting
background.

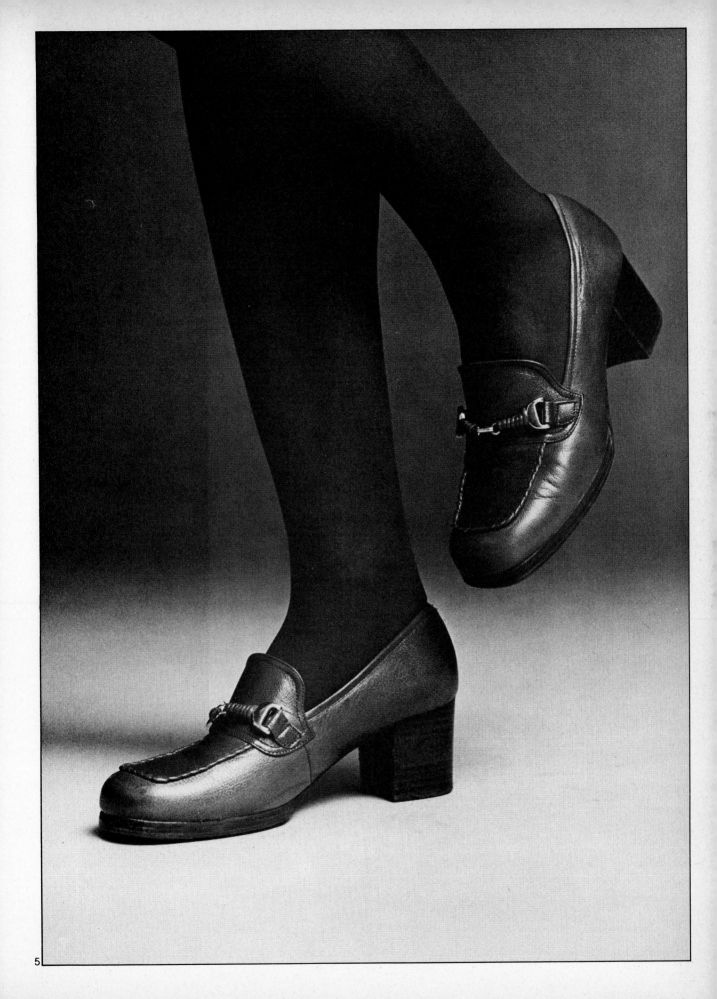

5

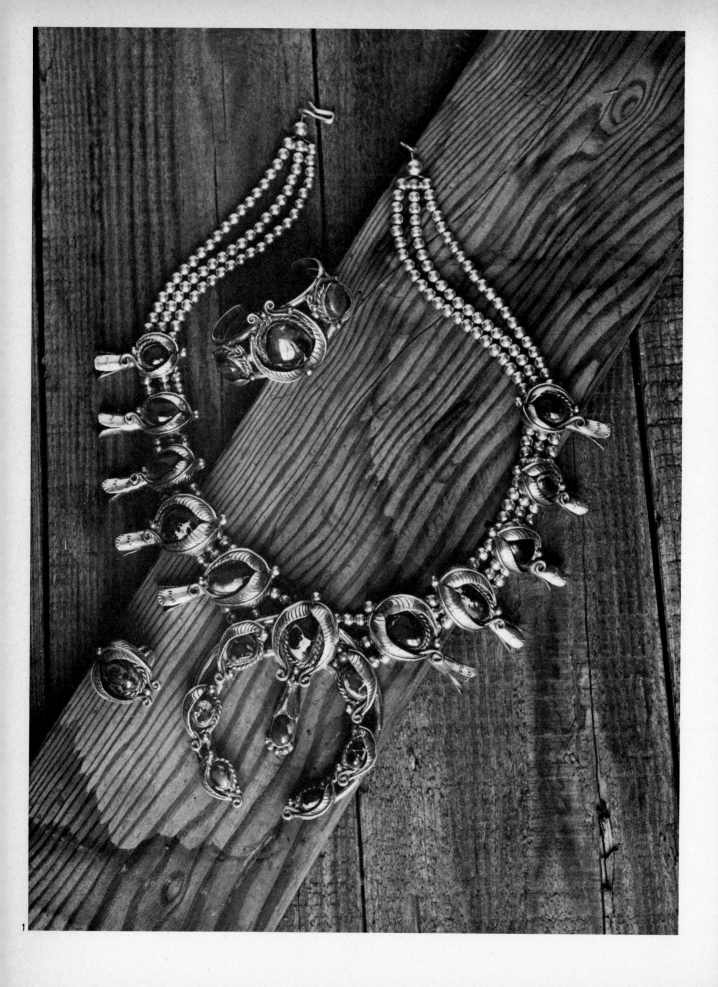

2

3

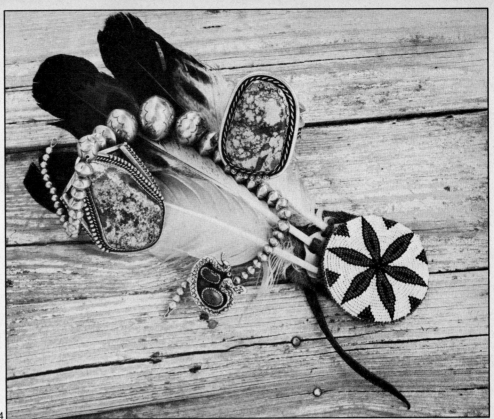

4

1-2. One large reflector was used to produce simple reflection in this jewelry shot.
3-4. Several reflectors were used to produce various directions of kick in jewelry shot.
5. Porsche patch on white sweater was originally shot in color. Lighting was produced by having subject stand in doorway and hold reflector to fill shadow side of the patch.

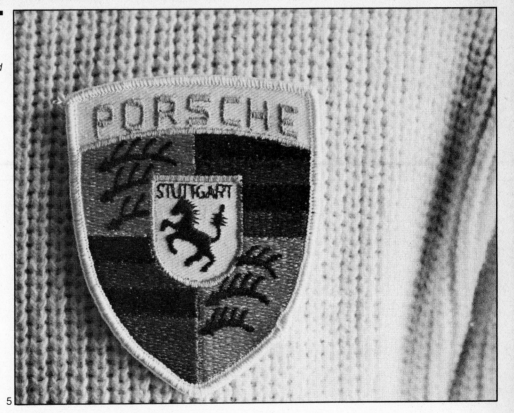

5

outdoor portraits

In the first chapter, we discussed lighting for people's faces, with very little control. In the second and third chapters, we learned lighting control with products that don't move. In this chapter we will cover photographing people who don't move.

Once again, we are back to six variations on a theme. However, while we wanted a good snappy print before, with portraits we want to back off on the contrast.

The first portrait was taken in open shadow. The straw background provided a built-in reflector, and combined with the open shadow, gave a very soft gentle lighting. The fact that the model was wearing very light clothes helped me decide how to handle the shot. I simply exposed and developed normally and went into the darkroom where I ovalled the print to give me a feel of the pose.

In portraits, after the lighting and location are selected, the most important thing to remember is that the first thing anyone viewing the picture is going to look at is the eyes, then the expression, and last, the entire picture to receive a feeling of the shot. If an ovalled print, or a toned print or a vignetted picture adds the final touch to the feel of the portrait, the whole thing comes together much better.

When you have a very gentle lighting setup to work with, as here in open shadow, try to find a very simple location for the picture, something that the subject can blend with, but where the subject is still the most important center of interest.

The second example is a portrait using directional shadow lighting. Here, as

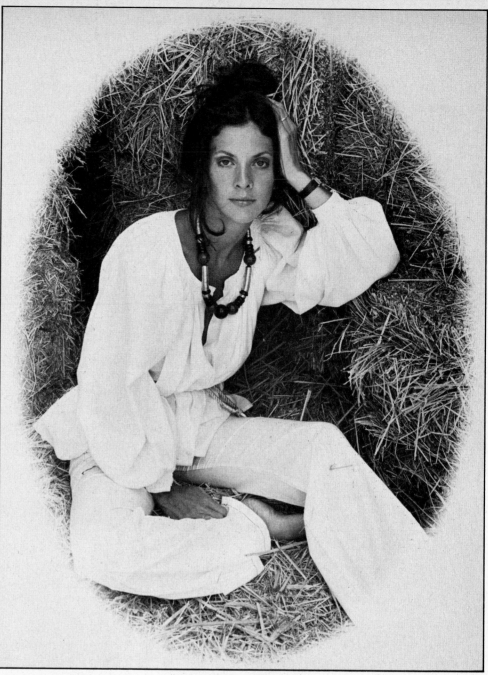

mentioned in the fashion chapter, you use the heavy edge of trees or buildings to stop the light from hitting the subject. Because the light here is nondirectional, you could slightly overexpose the negative to give that extra touch of density, but with a portrait subject you would not overdevelop.

As you can see in the setup picture, the subject was standing in the edge of an overhang with a building directly to his right. The overhang stopped any light coming from the top and side, and started forming the direction of the lighting. The building on the right stopped the light from that side, which left only light from his front left area to light him. The camera was placed close to the building to heighten this effect. By a slight adjustment of the camera position, both broad and narrow lighting could be used with this setup.

The third shot was made with the sun as a backlight rim, with the face lit in a gentle pattern by use of a reflector. With the sun coming from behind the subject, it's best to use someone with dark hair and dark clothes, as a blond or light-clothed person might reflect too much light and

2

4

3

5

1. Open-shadow portrait of model Shelia McElwaine demonstrates how simple location and ovalling of print can add to feeling of a portrait. Soft, gentle lighting is typical of open shadow.
2-3. Setup shot shows how portrait of David Donley was made using directional shadow lighting in Rembrandt-like pattern.
4-5. Backlighting was used for portrait of Thomas Killam III. Hand-painted backgrounds are by Lorene Charis.

become disturbing to the viewer. Also, using a darker background will show off the rimlit effect in a more striking manner. Your exposure should be made with only the shadow and light from the reflector striking the meter. Do not overdevelop

with this lighting.

In the example, the sun was used to rimlight the cape and give a highlight separation between the subject and the background. I didn't take my own advice and use a dark-haired person, and you can see that I have lost all detail in what little hair does show. The setup shot shows that my subject was standing in the edge of the sunlight. Two reflectors were placed to his right, a large one to light his face and a smaller one to light the lower part of

the costume.

You will find that many times the intensity of the light from the reflector will be disturbing to your subject. This problem can be solved by feathering (angling the reflector slightly).

The fourth example again makes use of the sun and a reflector, but the sun is not shown in the picture. This technique is especially useful when photographing a subject under the edge of a roof or a dense tree, using

the reflector to bounce the light and create a pattern with a gentle direction. The size of your reflector will control the intensity of the light. You can use two reflectors to obtain lighting ratio and pattern control. If you have two reflectors, use the larger reflector as your key (main) light, and the smaller one as your fill light. When both the lighting pattern and contrast are controlled in this manner, no exposure or development compensation is needed.

The fifth portrait was shot in direct sunlight. The low angle of the sun plus the use of a reflector gives you a lot of lighting and contrast control in this situation. The contrast can be lessened by moving the reflector closer to the subject, or increased by moving the reflector away from the subject. Depending on where the subject is facing and the location of the reflector, you can use most of the standard lighting setups—loop, split, Rembrandt—in either broad or narrow form. In this situation, you should overexpose ½ to one stop and underdevelop 20 percent to reduce the contrast (if the subject is wearing white, don't overexpose). Use a simple background to allow your subject to stand out, and use the sun to light the face in an attractive pattern.

The last example is direct sunlight with no reflector. This setup is the same as the one in the fashion chapter, but with a portrait background. Keep the background as simple and as out of focus as possible—use a slow film, so you can shoot at a large aperture. Remember that the only important thing in portraits is that the face be in focus, particularly the eyes. If you have too much contrast, as is the case here, keep away from close-ups. □

1

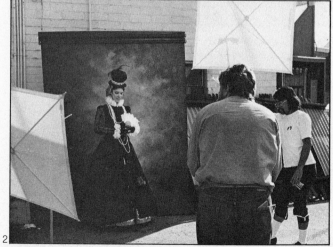

2

3

1-2. Model Marci Baxter was lit in a broad loop lighting pattern with a 3:1 ratio, using large reflector as key light and smaller reflector as fill light. Light ratio was controlled by using larger reflector to keep light from hitting smaller one. Even though larger reflector was the key, the smaller one reflected more light, because it was at a more direct angle to the sun. By stopping light with larger reflector, intensity of smaller one was kept less than key.

3. Direct sunlight shot of model Alberta Walker was exposed normally and underdeveloped to reduce contrast. Reflector was placed on ground directly in front of model, and adjusted to light her from waist up, as this is the important area. Notice that broad lighting is used to separate her face from equally light background. In narrow lighting pattern, shadow side of her face might blend with the background.

4. For shot of Jesse Loco, I used slow film and 250mm lens to keep background out of focus. Print was made using old developer to reduce contrast, and face was dodged slightly to allow the rest of the picture to darken down, to emphasize face.

4

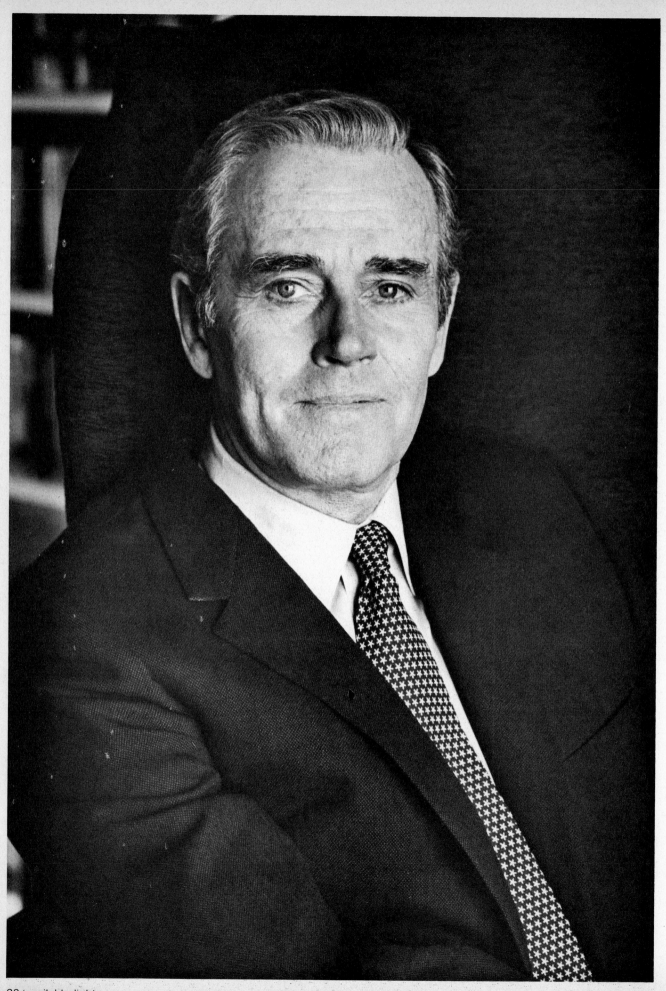

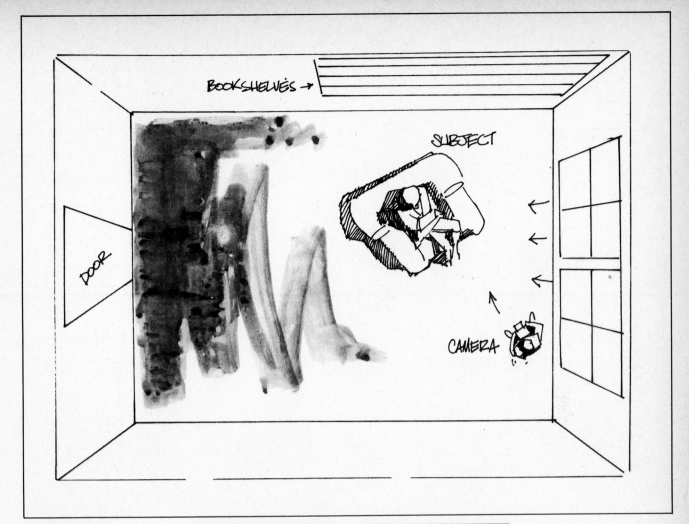

Labels within the diagram: BOOKSHELVES →, DOOR, SUBJECT, CAMERA

indoor portraits

Henry Fonda was lighted by one window directly to his left. His chair was angled slightly toward window to provide modeling on his face. Even though he was close to the window, resulting in a soft lighting pattern, there was still too much contrast—the side of his face toward the window was about six times (2½ f-stops) brighter than the shadow side. By overexposing the film about 20 percent and underdeveloping 10 percent, I was able to compress the film (reduce the contrast) and make this difference appear as I wanted it to appear. The shot was made with a 135mm lens on a Mamiya C-220 camera.

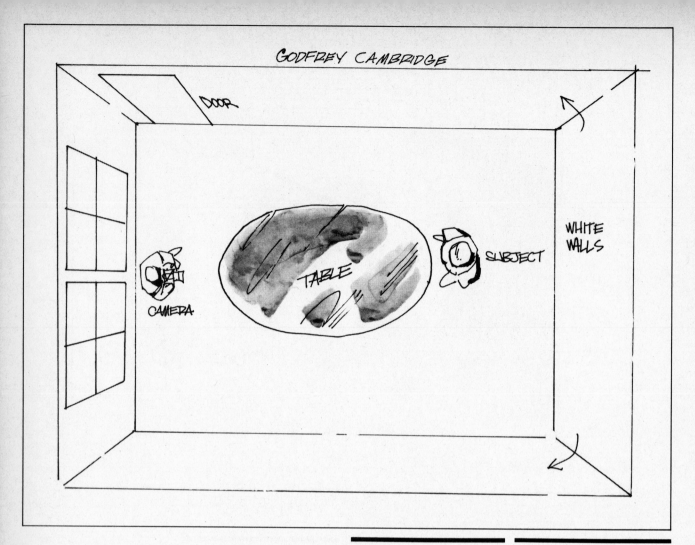

GODFREY CAMBRIDGE

DOOR

WHITE WALLS

TABLE

CAMERA

SUBJECT

Godfrey Cambridge was lit by one medium-size window directly in front of him. You can see this window reflected in his eyes. The shot was quite easy to do. White walls and a table were used for fill-in lighting. Exposure was for the white wall behind the subject, to make sure it would print white. The bottom of his turtleneck was dodged out during printing. This shot was made with a 135mm lens on a Mamiya C-220 camera.

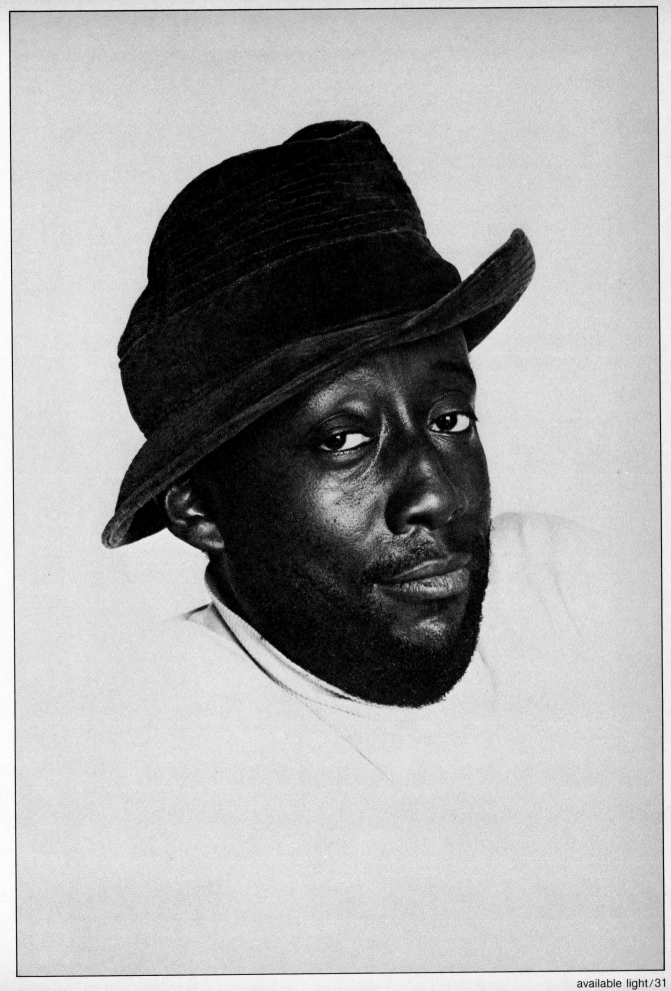

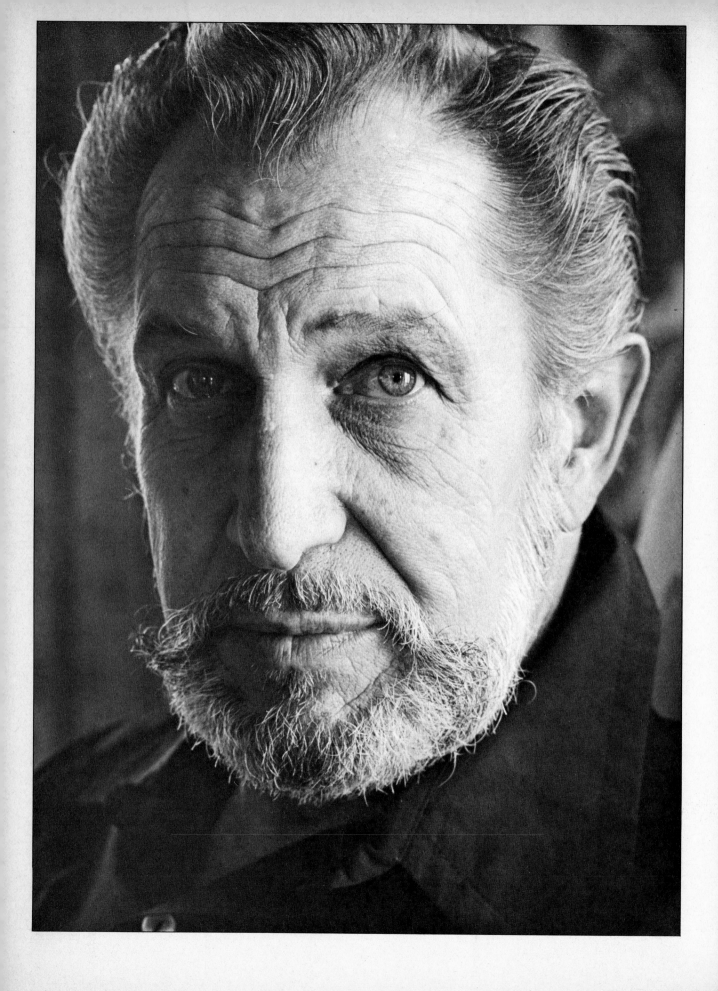

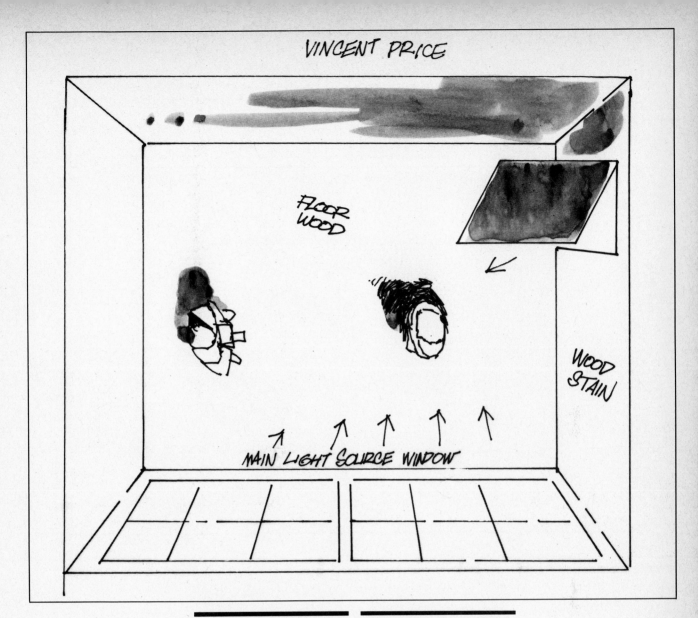

VINCENT PRICE

FLOOR WOOD

WOOD STAIN

MAIN LIGHT SOURCE WINDOW

Vincent Price was photographed next to a full-size picture window, in a split lighting pattern, which means that a slight kicker light was provided by an open door to his right and behind him. Because of the gentleness of the window lighting, the contrast was good, but I slightly overexposed the negative to produce the effect I wanted. The photo was made with a 180mm lens on a Mamiya C-330 camera.

ERNEST BORGNINE

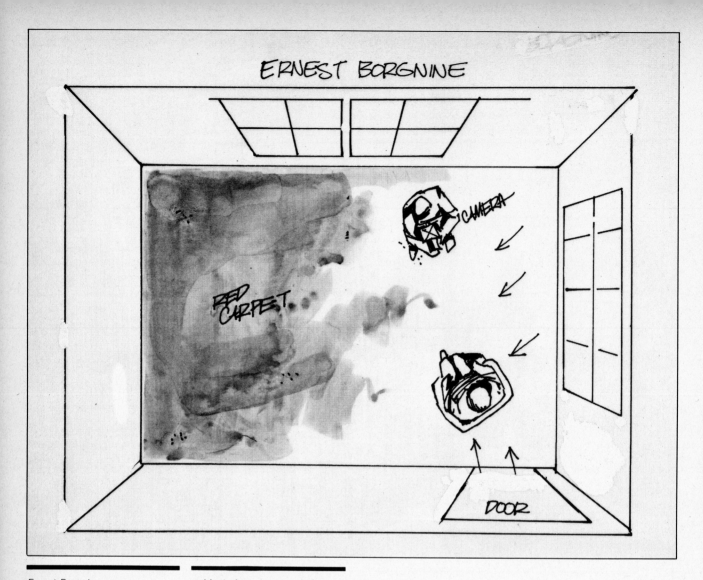

Ernest Borgnine was photographed sitting between two windows. In this situation, the contrast ratio can be adjusted simply by moving the subject closer to one window and farther from the other. This is the ideal lighting situation, as it allows you to choose your lighting pattern as well as the lighting ratio (contrast). The two windows were exactly the same size and 90 degrees apart. I moved the subject closer to one window until I got the desired lighting ratio.

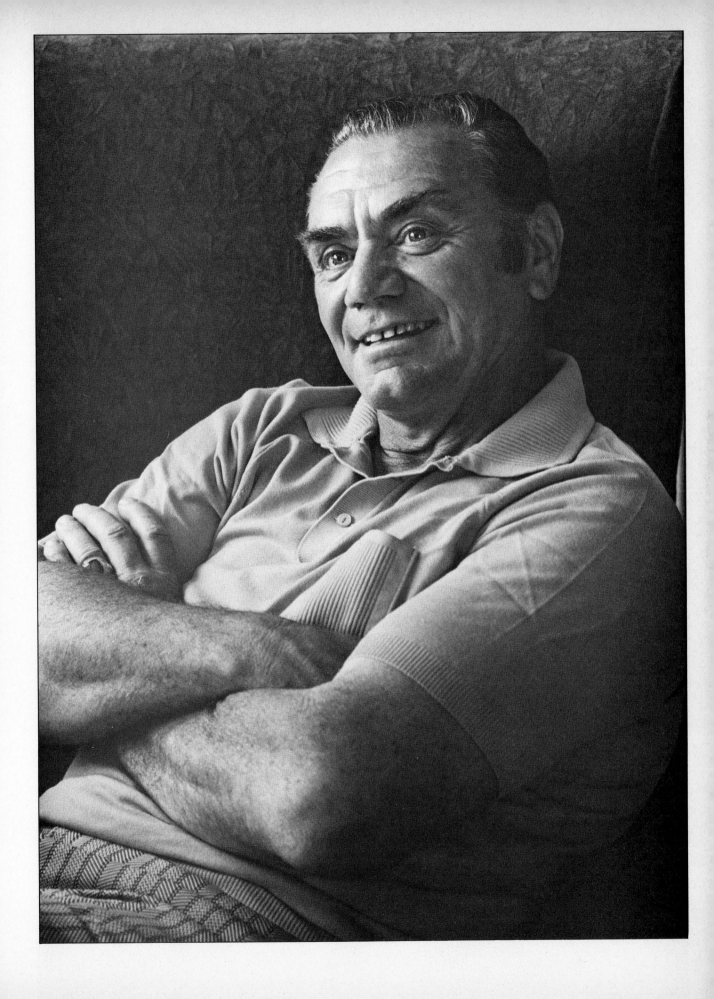

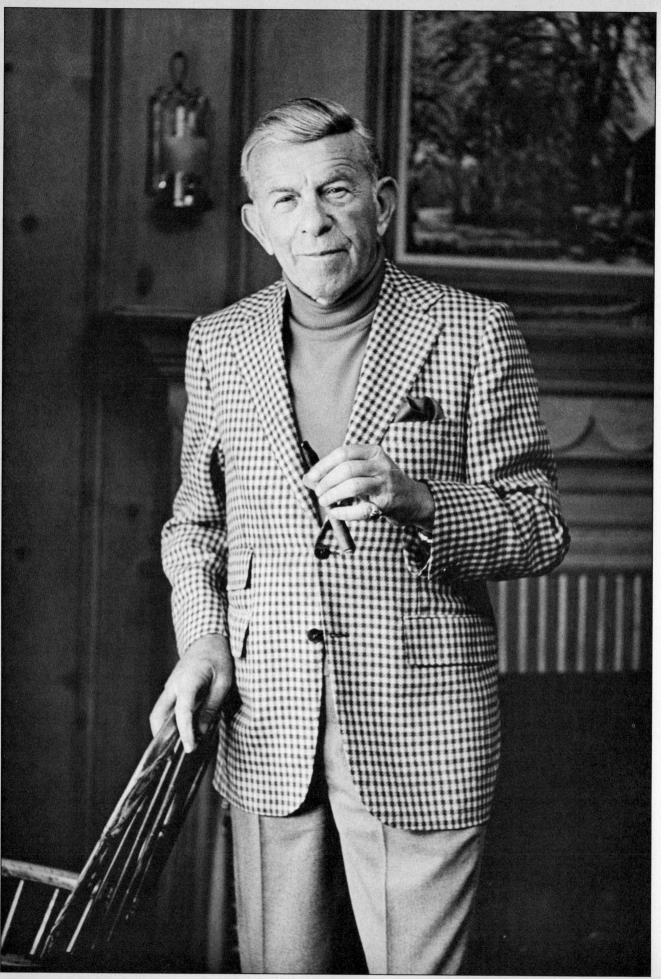

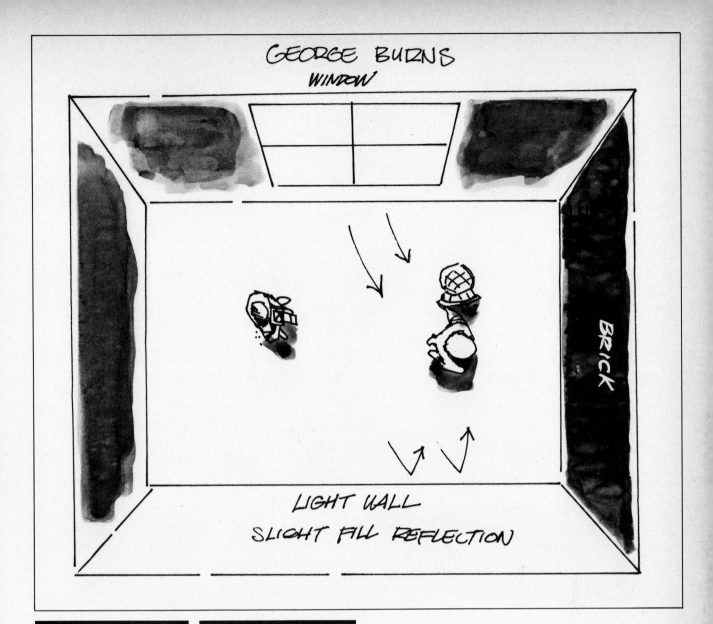

George Burns was photographed in the middle of a small room, using the one window to his right as the main light, and light reflected from the wall to his left as the fill.

One problem encountered in this open room lighting is that you can't really see the contrast, at least not so easily as you can with the subject close to the window. The safest thing to do here is to meter the contrast; take a reading from the bright side of the face and another from the shadow side to determine the difference. In this case, the difference was three f-stops. I quickly corrected this by rating my film one stop less (overexposing) and underdeveloping 20 percent.

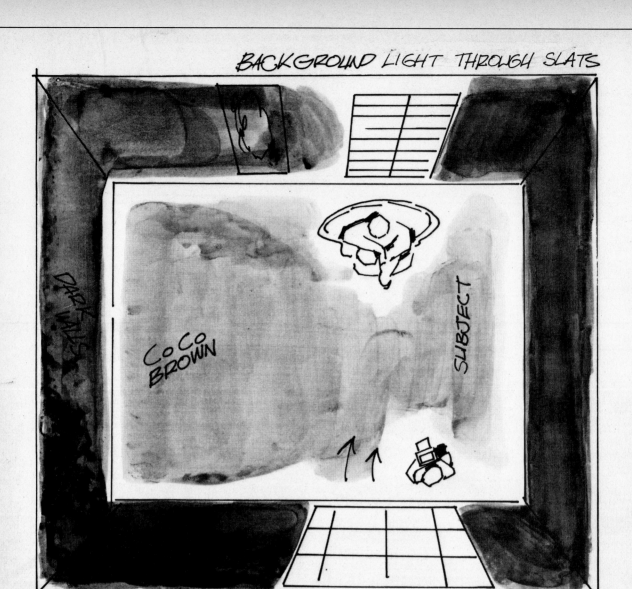

BACKGROUND LIGHT THROUGH SLATS

COCO BROWN

SUBJECT

GENE HACKMAN

Gene Hackman was lit by one window directly in front of him, in a variation of the open room lighting setup. There were no light walls to use as reflectors, so the window was used as a single, soft light source. The contrast here was excessive (the meter showed a three-stop difference between highlight and shadow sides of the face), and I overexposed two stops and underdeveloped 30 percent to get a negative that would print with no dodging or burning.

The secret to indoor portraits, as you have probably seen by now, is to be aware of the contrast, which is generally excessive, and control it by positioning the subject properly and exposing and developing the film properly for the lighting you are using.

color

Most of what has been said in the other chapters of this book applies equally well to black-and-white and color photography. The big difference between the two is that you can't overexpose and underdevelop color film for contrast control the way you can black-and-white. Your contrast control with color films lies mainly in finding or producing lighting conditions with the contrast you want. You can slightly overexpose transparency films or slightly underexpose color negative films to produce a pastel effect, which tends to reduce contrast a bit, but reducing the development will usually result in unacceptable color rendition. You can push-process color films by underexposing and increasing the time in the first developer, and gain some contrast along the way, but the usual problem with color is that it is too contrasty to begin with.

One important consideration when shooting color photos by available light is color balance. Of course you should use the proper film for the scene's dominant light source (daylight film for most available-light situations), but consider also the color of buildings and other things you use as reflectors. A red building will reflect red light onto the subject; green foliage will reflect green light onto the subject. The color of the light reflected by such objects makes little difference in black-and-white, but it can make a large difference in color shots.

North light and skylight are relatively "cool" or blue. Sometimes this bluishness enhances the photograph, but sometimes it does not. Excess blue can be removed by using a skylight filter or a yellow filter like the No. 81.

Another consideration in color work is color contrast. In black-and-white, red and green reproduce as about the same shade of gray. In color, of course, there is a marked difference between the two colors. This can be good or bad. If you are shooting a close-up of a red flower against green leaves, it will be much more effective in color. But if you are shooting a portrait, colored objects in the background that might blend into an unobtrusive gray tone in black-and-white could prove quite distracting, so keep an eye out for color contrast when shooting color.

If the light level is low, it's best to use the faster color films, like Kodak High Speed Ektachrome or GAF 500, for color work. Besides their relatively high speed, these films can be push-processed to allow exposure at even higher speeds (up to the neighborhood of EI 1000). You'll usually get better results using a faster film than push-processing a slower one—use High Speed Ektachrome rather than pushed Ektachrome-X, for example. The Kodachromes (25 and 64) cannot be push-processed, as explained in the chapter on low-light photography. When "pushable" color slide films are push-processed, there is an increase in grain and contrast and a loss of color fidelity, but these are usually acceptable when the alternative is no picture at all. Color negative films do not take to push-processing as well as color slide films, and you'll get best results by using a fast color slide film if you need a really fast color film.

Contrast is the primary problem in color available-light work, as mentioned earlier. Black-and-white film has better latitude, and you can compress a contrasty scene by overexposing the film and underdeveloping it. Since altering the processing of color films toward underdevelopment usually results in unsatisfactory color rendition, it is best to adjust the lighting so that the contrast of the scene is no greater than 1:4 (highlights two stops brighter than important shadow areas). This can be done by using the methods discussed in the other chapters of the book. □

Photo of Edward G. Robinson was taken in late afternoon, which accounts for warmish appearance. Subject was positioned so that porch roof threw shadow over the background, producing gradation. High Speed Ektachrome film in Mamiya C-220 was underexposed ½ stop for existing light.

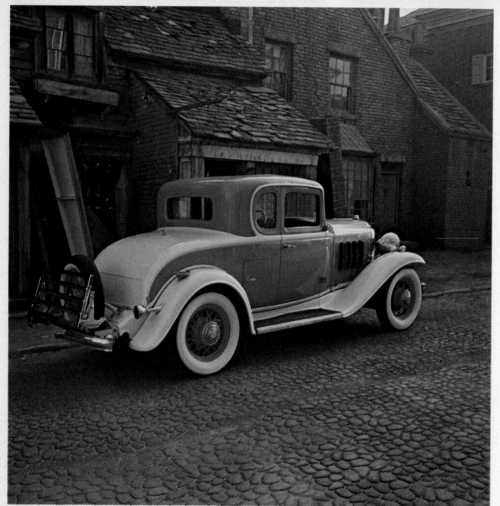

1. This wine setup is an example of cheating. I didn't spend hours setting up the scene—I found it in a flower shop and simply added the wine bottle.

2. Robert Goulet portrait is shown full frame to illustrate lighting. Very large picture window to his left side has created flare, but this is eliminated when picture is cropped to standard 8x10 format. By working so close to window, an additional touch of softness will be produced in portrait.

3. Old car was photographed with only open sky for lighting, on a roll of outdated Ektachrome film. This film sometimes goes warm with age, which compensated here for coolness of open sky lighting.

4. North light produced soft effect for portrait.

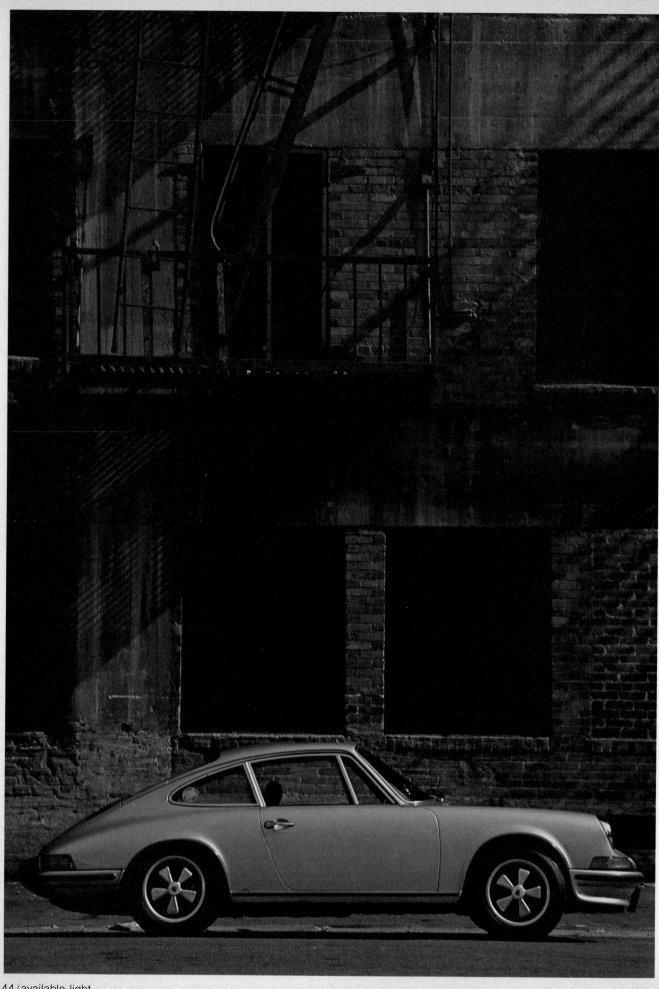

1

1. Sports car lit by direct sun was underexposed 1½ stops so that only major details of car were emphasized.
2. Monochromatic sunset is a grab-shot scenic. High Speed Ektachrome was underexposed three stops from normal meter reading.
3. Shot of model Ellen Fletcher shows obvious lighting color difference between reflected sun and open sky. Using both in same shot is not normally recommended for color work, but can at times prove to be effective.
4. Abstract of leaf and twig on red brick patio was shot on Kodachrome II, underexposed 1½ stops.

1. The secret to making pastel color photos is to keep the lighting on the flat side, then overexpose the scene about ½ stop. If the scene is too contrasty, the overexposure will wash out the highlights.

2. "Lonely flower" abstract was shot in open shadow on Kodachrome II. Shot was overexposed ½ stop to heighten the pastel effect.

3. Abstract of old car was made in direct sun on Ektachrome-X, underexposed ½ stop to give more color saturation. Abstracts have a slightly less identifiable image if the shot is either over- or underexposed to the point where it is out of the normal seeing range.

4. Reflector fill produced transparent shadow in this indoor product shot.

3

5. One of the dangers of color is shown by this shot. Both flower and leaves are well lit, but background is three stops darker than rose. With this 1:8 contrast ratio, the leaves hardly record on the film. Best color ratio is usually a two-stop (1:4) difference between highlights and shadows.

5

4

1

1. This is my favorite Vincent Price picture. I like to think that this is how he is, while the shot in the indoor portrait chapter is how most people would see him. The lighting was by an open window, with enough fill light from another window to make the lighting almost flat. High Speed Ektachrome was rated at a speed of EI 320 and push-processed to add some contrast.

2. Violin and rose were shot using north light window. Note the soft effect of this lighting.

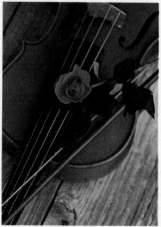

north light

Wherever you work taking pictures, you can usually find some sort of a window or door where the light shines through. North light is created by placing a sheet or other translucent material over this area and using it as a soft source of light. As with an overcast outdoors, here you have a light that is soft almost to the point where you lose all contrast. The examples shown will show how to deal with this.

The first picture caught the model wearing a '40s-style outfit. North light is perfect for this type of setup because it has the flavor of the old-fashioned lighting. I'll admit I cheated for this shot—I used a 500-watt Smith-Victor light on the side to provide a slight kick. However, whether you decide to cheat or not, the problem with this setup is to check for even background lighting. This may be uneven because of the angle of the light. Meter the entire background area that is in the picture to make sure it is reflecting an even amount of light into your lens. If not, this can be corrected by angling the background toward your light source window.

Because the model's clothes were dark, and the lighting was gentle, it was necessary to overexpose the film to produce the desired density on the negative.

In the second picture, the same model was dressed in a different gown, and the window was directly in front of her rather than to one side as for the first shot. Here, the thing to check is for evenness of lighting from top to bottom in the picture. Meter the scene from top of frame to bottom, and make sure the lighting is the same. The combination of light gown and gentle lighting made it possible to expose and develop the film normally without any loss of detail in the gown. Had I wanted more contrast in the print, I would have printed for it, rather than develop for it,

in order to preserve the fine detail.

The third shot shows in more graphic detail the effect of proper exposure and development for

sensitive subject levels. White-on-white subject matter is one of the most difficult shots to handle. Here, I metered for the model's white dress, not the background. This allowed me to carry as much detail as possible with normal exposure and development. If more contrast were

With the north light window at an angle to the subject, the problem is not the lighting on the model's face, but the lighting on the background. Correct this by turning your background toward the window. Model is Patrice Chanel.

desired, it could be printed.

Both of the prints shown were printed identically, but one was photographically enhanced (or in common language, retouched). By taking a fine spotting brush and drawing on the print a few of the fine details of the gown, I brought out things that would not ordinarily show up even in a well-lit picture. This is why many of the pictures you see in magazines and want to try to copy according to the lighting pattern can't be done. They are more than just straight prints.

The next print is a black-on-black situation. Here, there is plenty of subject contrast (black gown and background, white skin), but the usual lack of lighting contrast typical of north light. As mentioned before, you must overexpose 50-100 percent when shooting black to get detail when using north light. I underdeveloped the film 20 percent, but this resulted in a print that was too flat, so I added enough print contrast for facial detail, yet retained detail in the black gown.

The last two examples are probably the best uses for north window lighting—beautifully soft head shots. The second was taken under the same conditions used for the shot of Godfrey Cambridge in the indoor portrait chapter. I metered for the white wall, and in the darkroom dodged out the bottom of the print. Unlike the portrait of Godfrey Cambridge, however, this portrait contains a model and background of almost identical light value. Since the model is closer to the light source than the wall is, by reading for the wall, you are actually overexposing the model. This, combined with a slight underdevelopment, will prevent her from merging with the background and will retain the detail of her facial features. When the print was finished, it was still a little flat, so I spotted the eyelashes to make them appear black and achieve the effect of contrast. Once the eyelashes were

1

darkened, the picture seemed to come to life. Even though the subject matter is lacking in contrast, the presence of a black area

(the eyelashes) gives a feeling of contrast to the print.

In the first head shot, the model was turned slightly away from the window to provide a good loop lighting pattern. The minute she turned to the side, though, most of the light reflected from the side of her face disappeared, so I overexposed by 50 percent. Contrast was added during printing, rather than by overdevelopment of the negative. If this lighting pattern isn't gentle enough for you, move her further from the window. You will often find the use of a reflector to soften the

contrast will help.

You'll find very quickly that the north light window is great for many soft, gentle looks, in both color and black-and-white, and short of an entire Hollywood lighting setup, there is nothing as soft and gentle as window light. □

1. When background is directly in front of north light window, problem is top-to-bottom lighting evenness. Check evenness with light meter. Model is Patrice Chanel.

2-3. One of these was done with strobe, the other with window light. Can you spot the strobe shot? Model is Elizabeth Robinson.

2

1. *Black-on-black with a white face means high scenic contrast, while north light provides low lighting contrast. Here, film was overexposed to carry detail in black, and underdeveloped to retain detail in face. Model is Mercie Butler.*
2. *Watch out for light fall-off when your subject turns her head away from the window. You might have to overexpose to compensate. Model is Sharon Taraldsen.*

3. *"Cosmetic" head shots are ideal use for window light. Gentle, soft light removes many natural flaws. Model is Peggy Serdula.*

3

scenics and abstracts

As you grow in photography and start to develop your own style, you'll also develop areas of specialty. You'll find that you enjoy photographing some subjects more than others; these are the areas you should concentrate on. When you take pictures of what you enjoy, you'll quickly learn the ins and outs of that field, along with the little gimmicks and tricks that the photographers in that area use. My preference, which is obvious in this book, is people. When you photograph a person, that picture can't be copied or ever taken the same way again. If your interest is people, or something other than people—no matter what it is—you can develop a talent in that area and be successful with your pictures.

One field that interests many people is scenic photography. As far as scenics are concerned, the most important thing is to use a tripod. This will allow you to use small lens apertures for maximum depth of field, and slow films that give a wider range of tones and fine grain, without blurring of the image due to camera movement. Most professional scenic photographers use large-format view cameras, but you can get nice photos with any camera.

Most scenic photographs can be improved through the use of filters. For black-and-white work, a deep yellow or red filter can darken a blue sky and make white cloud formations really stand out. A polarizing filter can reduce or eliminate unwanted reflections from water, and also darken the sky. Using a red filter plus a polarizer will result in black skies, which can produce spectacular results with cumulus cloud buildups. Using the red filter with black-and-white infrared film will produce black skies and white foliage. A green filter used with panchromatic black-and-white film will lighten the foliage for pleasant results if the scene consists mostly of foliage.

For color scenic work, the polarizer can darken the blue sky to make cloud formations stand out, and it will also produce better color saturation by eliminating or reducing some of the reflections that tend to desaturate colors. A skylight filter can reduce the bluish cast in shadows.

If you don't have the money or time to travel to good scenic photography sites, an excellent way to show your photographic eye to those viewing your work is to do abstracts. Always carry your camera with you, because opportunities for

1

1-2. Composition rule of thirds calls for dividing frame into thirds vertically and horizontally, and putting center of interest at one of the intersections created by dividing lines. Other things that went into producing this print are shown in diagram.

2

abstract photography are everywhere.

It's kind of hard to spot these opportunities at first, but as your eye develops with experience, you'll begin to see photographic possibilities in many things. Look for the small things that people won't immediately identify with, or that the untrained eye would miss. The best abstracts are often unique angles or tight close-ups of common, everyday items or scenes. □

1-4. Series of close-ups was taken at train yard amusement park. Moving in close to familiar objects is common way to produce abstracts.

5. Star filter and 1½ stops of underexposure enhanced puddle in asphalt parking lot with sun reflecting directly into water.

6. Tri-X film was underexposed one f-stop to cut detail in abstract of iron grate with sun reflecting in water after brief rain.

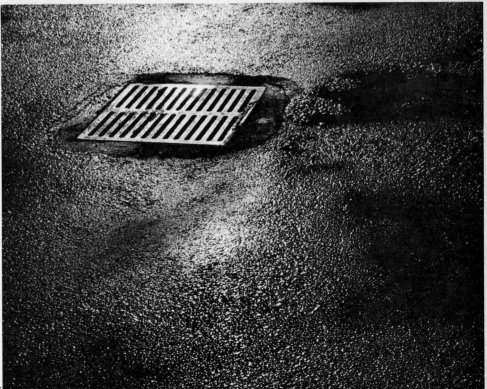

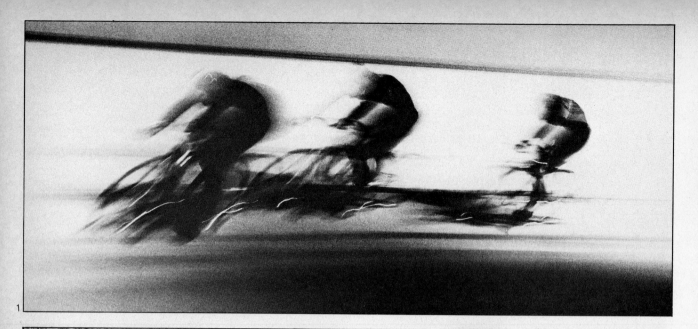

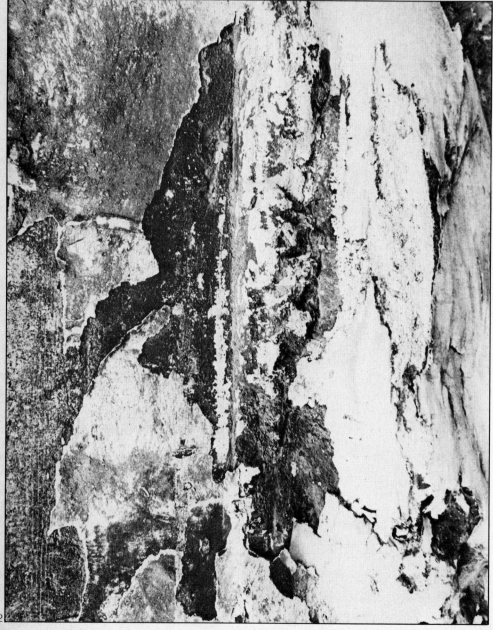

1. Camera was panned to follow bicycle racers during one-second exposure. Print was made on grade No. 6 paper.
2. Photo of peeling paint and plaster makes strange abstract when viewed upside down.

low light

The basic problem you encounter when there isn't very much light consists of three parts: 1) You need to use a fast enough shutter speed to keep camera or subject movement from blurring your photo; 2) you need to use a small enough lens aperture to provide sufficient depth of field to keep all the important things in the scene sharp that you want sharp; and 3) you need to let enough light hit the film to produce a usable image.

The first two considerations make satisfying the third one quite difficult, but the third one is the most important. You have to give the film sufficient exposure; the other considerations don't mean a thing if there is no image on the film.

In order to satisfy these three considerations, you're going to have to give up something. You can use a fast film, but fast films are grainy. You can use a fast lens, but large apertures mean no depth of field. You can use a long shutter speed, but this means you must put the camera on a tripod and shoot nonmoving subjects. When the illumination level is really low, you're not going to get as good quality photographs as you would under ideal conditions. But there are a lot of things you can do to get the best results possible.

FILMS

The best way to assure fairly good tone and detail in your low-light photographs is to use a truly fast film. The fastest continuous-tone black-and-white films readily available are Kodak 2475 Recording Film (film speed 1000) in 36-exposure 35mm rolls, Kodak Royal-X Pan (film speed 1250) in 120 rolls, and Polaroid Types 107, 47 and 57 (film speed 3000) in pack, roll and sheet form, respectively. These films are all pretty grainy, especially the 2475, and the Polaroid films do not produce a negative from which enlargements can be made, but they are all fast, which means they'll all record better shadow detail than other films.

For color photography under low light levels, GAF 500 Color Slide Film (film speed 500) and GAF 200 (film speed 200) are the fastest, with Kodak High Speed Ektachromes Daylight (film speed 160) and Tungsten (film speed 125) rounding out the field. These color slide films can be "pushed" to higher film speeds, at the expense of some increase in grain and loss of color fidelity. You won't get that nice Kodachrome II look, but then you wouldn't get an image on KII under very low light levels.

1-2. Black-and-white films are not quite as sensitive to tungsten lighting as to daylight. Here ASA 400 film was rated at 800 to use fast shutter speed to stop action of water hitting Alan Sues during Laugh-In TV show, and film was overdeveloped to compensate. As you can see from the muddy look of the prints, the negatives thus produced were quite weak. I can't figure whether Jack Soo is complaining about the wet Alan or the poor condition of the print.

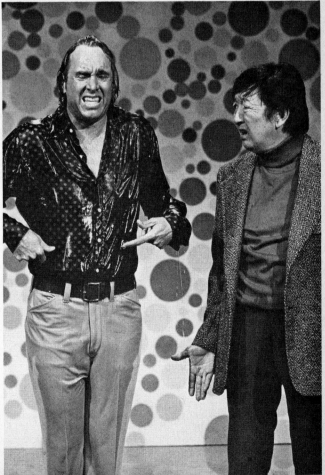

PUSH PROCESSING

Color transparency films like the ones just mentioned can be push-processed to higher film speeds by increasing the time they are in the first developer. Many custom labs will push-process these films. From one to three times the rated film speed can be gained in this manner, at some loss in quality (i.e., increased grain and loss of color fidelity). Kodachrome films cannot be push-processed, because they are processed with special chemicals and complex equipment that are not suited for altering processing times.

Negative films, both black-and-white and color, can be push-processed, but they don't really gain speed as a result. The bright highlight areas in the scene gain density on the negative, but the dim shadow areas do not unless they have received sufficient exposure, which they have not when the film is exposed at higher speeds than the rated one.

Nevertheless, there are some things you can do to black-and-white films to get better results under low light conditions.

First, you must realize that black-and-white films are not quite as sensitive to incandescent light sources as to daylight. These films are most sensitive to blue light, and daylight contains more blue than indoor light sources. Therefore, even though the film manufacturers give their black-and-white films just one speed rating, these films are about ⅓ to ½ a stop slower when used with indoor lighting. (You can prove this to yourself by taking a meter reading from an 18-percent reflectance gray card in daylight, and making an exposure accordingly based on the film's rated speed, then do the same thing under indoor

lighting, rating the film at the same speed. Compare the negatives—the one shot outdoors will be denser.)

Now when you consider that just about all low-light photography occurs when there is no daylight present, you'll see that under these conditions, when you need all the film speed you can get, your film is actually slower than its rated speed!

What can you do? Well, let's assume you're using a popular film like Kodak Tri-X or Ilford HP4 (film speed 400). Under the artificial

lighting that illuminates most dimly lit scenes, the film's speed will really be in the 250-320 range. The standard procedure to "push" the film speed one stop (double the

speed) is to increase the developing time by 50 percent. If you expose the film at a speed of 800, and overdevelop it 50 percent, you will get underexposed negatives lacking in shadow detail, and having a contrasty overall look. A one-stop increase in film speed under the nondaylight illumination would bring the speed up to 500-640, not 800. And even at the

500-640 rating, the film will be underexposed, because its real speed is 250-320 under these conditions. Overdeveloping the film will result in added negative density in the brighter parts of the scene, but very thin, underexposed negative areas in the dimmer parts of the scene, because these areas of the scene didn't receive proper exposure.

To see why this is, let's examine a characteristic curve for a film (see Figure A). A characteristic curve is just a graphic way of showing how much of an increase in density on the negative will be produced by an increase in exposure. Figure A is a rather simplified characteristic curve for a hypothetical film, which will make things simpler at first. Later on, we'll turn this curve into a real one to complete the picture.

It takes a certain amount of exposure to produce any density at all on the negative (above the density of the clear areas between the frames, which consists of the density of the film base and the fog produced by development). Let's say that point B on the curve represents the first noticeable image (or density) on the negative. We'll say that one unit of exposure produced this density. Therefore, all exposures of less than one unit—all exposures to the left of point B on the curve—will produce no density on the negative. We call point B the *threshold exposure*. It represents the minimum exposure that will produce density on the negative.

Point C on our curve represents an exposure one stop greater than the exposure that first produced an image on the film. Point D represents an exposure one stop greater than Point C, and so on. So along the bottom of the curve, we have started with one unit of

1, 4. After some experimentation, I discovered that rating the ASA 400 film at 600 for darker scenes like the one of James Coco and Ruth Buzzi, then closing the lens down ½ a stop for the lighter ones like the one of Ruth Buzzi alone, allowed me to use fast enough shutter speed for sharp results, yet still produce acceptable prints.
2. Shot of Lily Tomlin is from same batch of negatives as shots of Alan Sues, but print is acceptable, because there is no major black area to show that negatives were underexposed by reproducing muddy gray.
3. By exposing film at EI of 600 instead of 800, to compensate for speed loss due to tungsten lighting, and overdeveloping 50 percent, dark scene was recorded acceptably, although detail is lost in shadow areas due to underexposure.

exposure, then doubled the exposure, then doubled it again, until we have 1024 units of exposure represented by point L. Now let's look at the left side of our curve and see what happens to negative density as the exposure is increased.

From points B through J, we get a proportional increase in negative density for each increase in exposure. Each time we double the exposure, we get twice the density on the negative. The portion of our curve between points B and J is called the straight line portion of the curve, for obvious reasons.

(The slope of the straight line portion of the film curve varies from film to film. If the slope were less steep, which it usually is, then there would be less increase in density for each doubling of the exposure. But as long as the line is straight, each increase in exposure will produce the same increase in density as the last.)

Now let's look at the portion of the curve before point B. We already

explained that any exposure less than that represented by point B will produce no density on the film, because such small exposures are just too weak to overcome the film's inertia (resistance to exposure) and form an image.

Now let's consider the portion of the curve beyond point J. From point J on, the curve is horizontal, indicating that further increases in exposure produce no increase in density. At point J, the exposure is sufficient to produce the maximum density the film can have; further exposure can add no density.

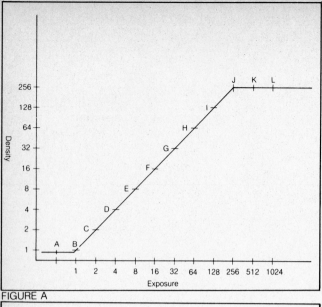

FIGURE A

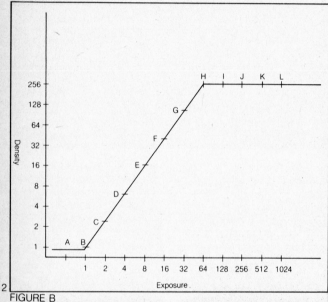

FIGURE B

1. Simplified film curve shows changes in density caused by changes in exposure. Point B on curve represents first noticeable density on negative, produced here by one unit of exposure. Point J on curve represents maximum density the film can produce. Any additional exposure will produce no additional density on the negative.

Each number along the bottom of the graph represents a doubling of the exposure (a one-stop increase). Note that the film represented by this curve has a seven-stop range of exposures that will produce different densities on the negative.

2. If film is overdeveloped, as in push-processing, the film curve becomes steeper. The significance of this is that now the same film has only a five-stop range of exposures that will produce different densities on the negative. The film has lost two stops of latitude. The highlight areas represented by points H and I, which were produced as different densities on the normally processed film (Figure A) are now produced as the same density as point J and those beyond it.

The useful range of our film, then, is from points B to J on the curve—from the point where the first noticeable density is formed to the point where the maximum possible density is formed. This represents a range of brightness of 1:256, or about eight f-stops. If the brightest object in a scene reflects 256 times as much light as the dimmest object, and we expose the film properly, the brightest object will be recorded at point J on the curve, the dimmest object will be recorded at point B, and we will have detail in both on the negative.

What does all this have to do with low-light photography? If we expose our 1:256 scene properly (meaning according to the true speed of the film), the dimmest object will be recorded at point B on the curve, and the brightest object will be recorded at point J, with all the other parts of the scene falling in between. Now, let's say we decide to "push" our film speed one stop, by exposing the film at twice its real speed. What happens?

We are basically moving everything in the scene down one notch on the curve. The brightest object in the scene will now be recorded at point I, which is O.K. But the dimmest object will fall at point A, which is not O.K.—it will not receive enough exposure to be recorded at all.

What happens when we overdevelop the film by 50 percent to compensate? Won't that restore the dimmest object?

No! It takes a certain amount of exposure to produce an image on the film. We determined that that exposure was represented by point B on our curve. We didn't give the film enough exposure to record the dimmest object. No amount of development can bring

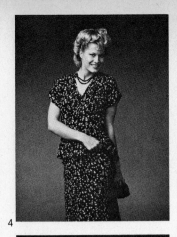

4

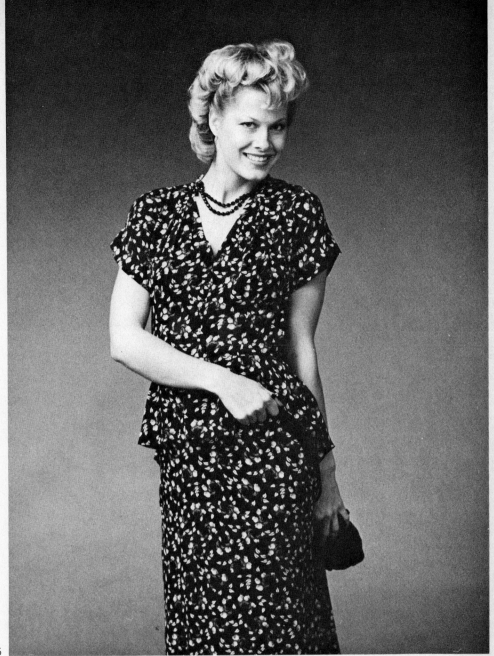

5

3. Print of model Susan Buckner was made from negative exposed to daylight source, according to meter reading and based on film's rated speed.
4. This print was made at same enlarger settings, from negative exposed to tungsten light source according to meter reading based on film's rated speed. Note underexposure of negative.
5. Here the tungsten negative was printed for its own best features. Note muddy look due to underexposure of negative.

out an image that isn't there in the first place.

What does overdevelopment do to our curve? It makes it steeper (see Figure B). And what does this mean? It means that the straight line portion of the curve now runs from point B only to point H. And this means that the densest image possible is now formed at point H instead of at point J. And that means the range of brightness we can record on our film is from point B to point H, or a range of 1:64 instead of the 1:256 range we had before. By overdeveloping we have increased the contrast to the point that we have lost two stops of brightness latitude.

In other words, overdeveloping has only added density do the brighter objects in the scene. If we underexpose the film by one stop, moving all the objects down one step on the film curve (and thereby losing the dimmest objects), we can build the density of the bright areas back up again by overdevelopment, but in the process we lose some film latitude.

This is why push-processing is

recommended only for scenes of low contrast. If a scene consists only of a few bright and middle tones, with a brightness range of only 1:64 (two stops less than the film latitude), we can underexpose it two stops with our example film, moving everything down two steps on the curve, and still record all the objects (see

Figure C). By overdeveloping, we can move the tones back up the curve and add some contrast to the low-contrast scene. But if the scene consists of only middle and dim tones, we can't underexpose it, or the dim tones will be moved below the threshold exposure—they will not register on the film (see Figure D), even if the brightness range of the scene is only 1:64.

If a low-light scene has a brightness range equal to or greater than that which our film can record, we cannot underexpose and

overdevelop the film without losing detail in the dimmer objects in the scene.

Now that you have a basic understanding of what's happening, let's turn our simplified curve into a real one. Figure E is a real characteristic curve. You will notice that it smoothly curves from the horizontal portion at the bottom into the straight-line portion, then smoothly curves into the horizontal portion at the top.

The smoothly curving portion at the bottom is

called the toe of the curve. Remember, we said that along the straight line portion of the curve, each increase or decrease in exposure would consistently produce a proportionate corresponding increase or decrease in density on the negative. Well, along the curving portions of the curve, this is not so (see Figure F). As we move from the straight-line portion of the curve into the toe region, each halving of the exposure produces correspondingly less effect on the density of the negative.

When we shoot real film, the dimmest objects in a scene are recorded on the toe of the curve, where a difference in exposure (or object brightness) produces relatively little density on the negative. For this reason, underexposure can record a lot of different dim objects as one thin density, and destroy all separation between them.

At the other end of the straight-line portion of the film curve is another curving portion, called the shoulder. The brightest parts of a scene are recorded on the shoulder of the film curve, where, again, a large difference in exposure produces only a small difference in density on the negative. If the film is overexposed, separation between the brightest areas and very bright but not that bright areas will suffer. By overdeveloping film, we are in effect lengthening the shoulder of the curve, causing the brightest objects in the scene to record as the maximum density the film can produce, and therefore losing all separation.

That's why it's best to rate the film at its true speed, so that your scene will be recorded primarily on the straight-line portion of the curve. In black-and-white photographs, all you have to reproduce your scene is tones of gray. If all the darker tones merge into

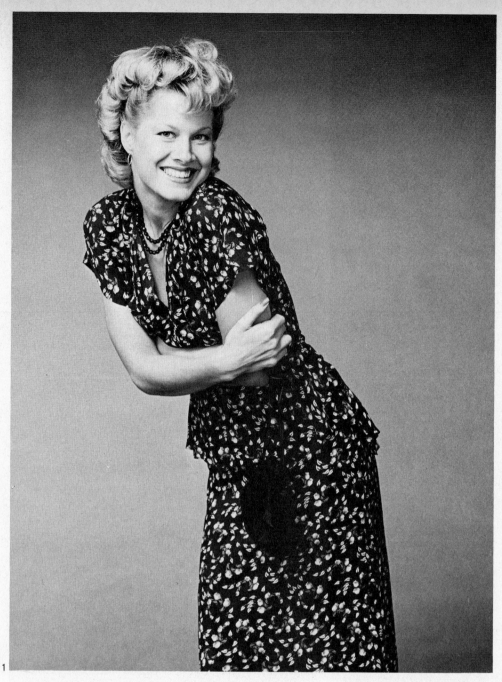

1

black (recorded on or below the toe of the curve) and all the brighter objects merge into white (recorded on or above the shoulder of the curve), your print will lack

detail and contain excessive contrast, and it will be bad.

LATENSIFICATION—Don't give up all hope, though. There is something you can do to increase film speed (aside from using a faster film, which is the best thing to do). Latensification is the name of the thing, and it basically means controlled fogging of the film to put an overall base density on it. In effect, you are moving the film curve up a step, the whole curve (see Figure G).

Latensification can be done chemically, or with light. The easiest way to do

1-2. These shots show the difference in quality between properly exposed (1) and one-stop-underexposed push-processed (2) negatives. Note excessive contrast, and lack of highlight and shadow detail in pushed print.

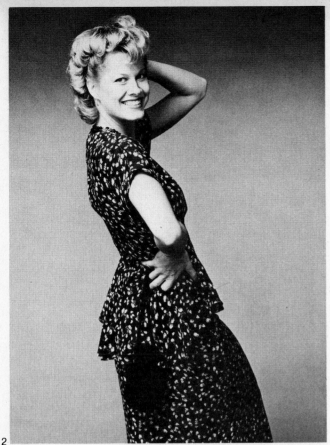

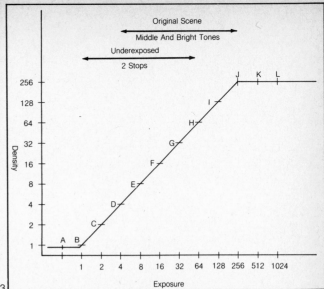

3
FIGURE C

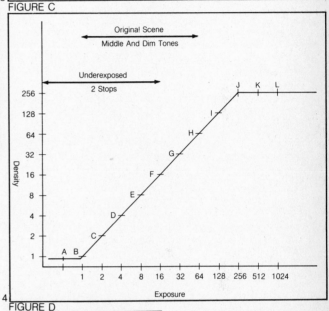

4
FIGURE D

it chemically is with a product from Unicolor called Plus-1, which was made to allow Tri-X to be pushed to a speed of 800, and it really works. The effect of this latensification is to add false exposure detail to the very weak (underexposed) shadow areas, and force some of this area to develop and print, as well as adding more grain to the print (you don't get something for nothing).

The same latensification process can be done using light. Take a roll of Tri-X exposed at a speed of 800 into the darkroom, and hang the unprocessed roll up as if you were drying it. Then, using a safelight, with two sheets of typing paper over the bulb, expose the film for one second with the safelight 10 feet away. Note: This process cost me four rolls of film before I got the exposure right. Test the procedure with the film you are using, in your darkroom, with your safelight before trying it on anything

important. You must produce only a *slight* fog for it to be effective.

Latensification with light seems to produce a bit more grain than the chemical method.

INTENSIFICATION— *Latensification* is a means of adding an overall density to the negative, so that even the underexposed areas have some density, and it is done before the film is processed. *Intensification* is a means of adding density (and grain) to the highlights of a weak negative, and is done after processing the film. The best results with intensification will come from an underdeveloped negative, not an underexposed one. Intensifier can intensify only the image that exists on the negative. An underdeveloped negative contains highlight, mid-tone and shadow images, but they are all weak. Intensifier can add density to all these image areas, but it will add mostly to the densest (highlight) parts. An underexposed negative probably does not contain any shadow image, and the intensifier can therefore only add density to

3. If a scene consists only of highlight and middle tones, and has a contrast range less than that which the film can record, then the scene can be underexposed with no problems.
4. If the scene consists only of middle and dim tones, we can't underexpose it, or the dim tones will be moved below the threshold exposure.

the highlights and mid-tones, producing a negative that may be too contrasty to print. Kodak Chromium Intensifier is an inexpensive and very good intensifier.

LONG EXPOSURES
Frequently under low-light conditions, you'll have to use long exposure times to adequately expose your film. There are a few things you should consider when making long exposures.

SUBJECT MOTION—If you

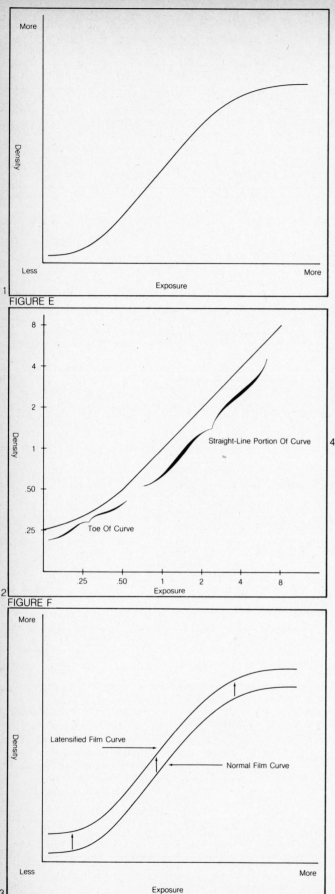

1

FIGURE E

2

Straight-Line Portion Of Curve

Toe Of Curve

FIGURE F

3

Latensified Film Curve

Normal Film Curve

FIGURE G

4

1. Real film curve looks more like this, with smoothly curving portions at bottom and top.
2. A given change in exposure produces less change in density on the toe or shoulder portion of the curve than on the straight-line portion.
3. Latensification adds an overall base density to the negative, in effect moving the entire curve up a step.
4-5. Chemical latensification does away with muddy, underexposed look of pushed film speed.

are shooting a sports event, or a rock concert, or anything else that imvolves moving subjects, making long exposures can present a problem; mainly, the subject(s) will come out blurred.

You can do a few things to minimize this blurring, though. If the subjects are moving steadily, such as horses in a race, you can pan the camera with the action. This just means you watch the action through the camera, steadily moving the camera to follow the action, and pressing the shutter button when it looks good, continuing to follow the action with the camera all the while. In this way, the camera is moving with the subjects, and the result will be a much sharper photo than if you had just tried to click the shutter as the subjects went by.

If your subjects jump around a lot, moving irregularly, like rock singers, you can try to shoot at the peak of the action. This means, for example, if the subject leaps into the air, there is a point when he stops just before he starts to come back down, as the action reverses. If you shoot right at that point, there is no subject motion, so you will get a sharp picture. (If your shutter speed is longer than the brief moment the subject hangs motionless in the air, you will get some blur, but the picture will still

be better than if you had shot at another point during the action with the same shutter speed.)

CAMERA MOTION—For peak-action shots, you'll probably be best off hand-holding the camera. Your camera's owner's manual probably shows you the proper method for holding it steady, but here are some additional tips:

1—Don't hold your breath while you shoot; instead, steadily exhale. That way you don't build up tension, which can cause you to shake.

2—Don't lean against anything that vibrates, although if possible you should brace yourself against something solid.

3—Keep your arms resting against your body in a natural relaxed manner. If you hold your arms up away from your body, they'll get tired and may shake a bit.

4—Use a short cable release or a soft-release button for your camera. This minimizes the chances of jiggling the camera while releasing the shutter.

For panning shots, and for shots of subjects that don't move, you should put the camera on a steady tripod. You can use the tripod's pan head (know why it's called that now?) for panning shots. For stationary subjects, adjust the camera position for best composition, then lock off all the tripod movements. Focus, then, if you are using a single-lens reflex camera, lock up the mirror (see owner's manual), so that the vibration caused by the mirror flipping up during the exposure doesn't blur things. Use a cable release or the camera's self-timer, to avoid jiggling the camera when depressing the shutter button.

RECIPROCITY FAILURE—Now that you know how to minimize blur during long exposures, here's something else to consider: With very long exposures (longer than about ½ second), films lose speed and color films have a color shift. This is called

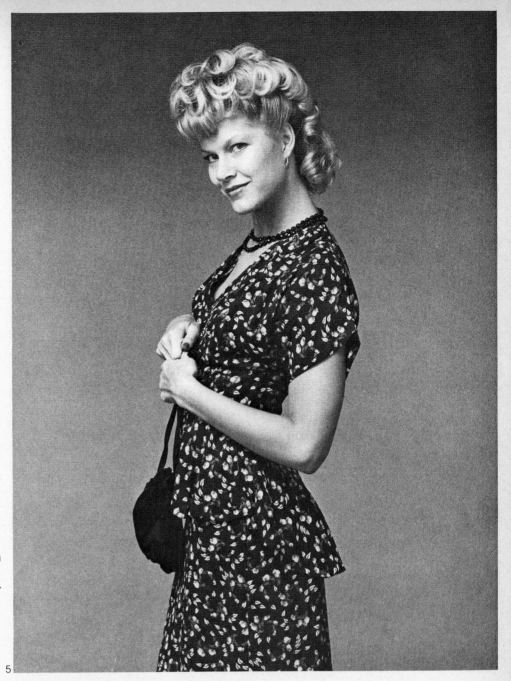

5

reciprocity failure, and it means if the light meter says to expose for ⅛ second at f/1.4, the equivalent f-stops for longer exposure times will result in underexposure. An exposure of ⅛ at f/1.4 should equal an exposure of two seconds at f/5.6, but it doesn't. Due to reciprocity failure, the necessary

exposure time at f/5.6 would be more like five or six seconds.

Most film manufacturers will send you reciprocity data for their films, if it is not included in the film instruction sheet. If you don't have this information, it won't hurt to give the film an exposure time twice as long as indicated by the light meter when the meter calls for one- or two-second exposures, increasing to three-five times the meter-indicated exposure at longer exposure times.

If you are shooting color slide films, you should shoot a test roll at the exposure

times you expect to be using, then see which way the color is off, and use an appropriate color compensating filter over the camera lens when shooting the important stuff. With color negative films, the color balance can usually be fixed during printing.

With black-and-white films, you should cut back your developing time about 25-50 percent in addition to the exposure increase, to reduce

1-2. Shots of model Marie de Angelis show effects of mechanical latensification. Compare these with chemical latensification shots on previous page—the results are pretty much the same.

3. This print was made from a negative that was underexposed one stop and developed for the normal developing time. The print is O.K., but lacks punch.

4. The negative that produced photo 3 was intensified, and this print was the result. Note how this print is similar in quality to photo 5. Using intensifier will help out an underdeveloped negative, but will only produce excessive contrast with a properly developed but underexposed one.

5. This print was made from a negative that was underexposed one stop and overdeveloped 50 percent.

the excessive contrast created by the reciprocity failure.

LENSES

Fast lenses (those with maximum apertures in the f/1.2-f/1.4 range) can be quite useful for low-light work. They provide a brighter image for focusing with SLR cameras, which is very important under low illumination levels. They also give you the option of using a faster shutter speed than would be possible with a lens that can be stopped down only to f/4. But the depth of field at f/1.2 or f/1.4 is about nil, and if some important subjects in your scene are closer to the camera than others, you might not be able to shoot at such wide apertures and retain sharpness in both near and far subjects. With

an SLR camera, you can see through the viewfinder whether all the subjects are sharp with the lens wide open; if they aren't, and

should be, stop the lens down until they are, and use the corresponding shutter speed, bearing in mind the limitations mentioned in the section on long exposures.

Some of the latest wide-angle and short telephoto lenses have speeds as great as those of some of the normal focal lengths, but most wide-angle and telephoto lenses are not so fast. This is a limitation, but not so great a one as you might think. Telephoto lenses have so little depth of field that apertures in the f/1.4 area would be nearly useless. Very large apertures

3

4

on wide-angle lenses are often not nearly as sharp as smaller ones. Again, you have to give up something to get something else.

LIGHT METERS

Another low-light consideration is your exposure meter. The meters built into modern 35mm SLR cameras are amazingly accurate under low-light conditions, but unless you have a lighted meter-needle display in the viewfinder, you won't be able to see what the meter says under low illumination levels. If the

5

camera has an exterior meter indicator, in addition to the viewfinder display, this might be easier to see. A small penlight flashlight is a handy item to take along, to help you read meter needles (don't use the flashlight to try to read the viewfinder display—it'll throw the reading off) and lens and shutter speed settings.

If you have a hand-held meter, you'll get better results from a CdS type than from a selenium cell type, as the former has greater sensitivity—it will read light levels too low for the selenium cell to read (although if the light level is that low, you'll probably have problems getting photos anyway). □

action and night

Before getting into photographing action subjects, a few words about a type of action that ruins more pictures than anything else: unintentional camera movement.

As you can see from the pictures in this book, I shoot a great variety of subjects, although my primary interest is people. I put my camera on my top-quality very light aluminum tripod for nearly every shot I take, and I'd suggest that you get such a tripod and use it, too. You'll find that you can make larger enlargements from your negatives if you use a tripod, because your negatives will be sharper, even at fast shutter speeds. The shake of your hand or the vibration of the shutter itself can destroy sharpness, and a tripod will make a visible improvement in your photographs.

Your primary concern in action photography is to show, not necessarily stop, the action. Generally you will want to use a fast shutter speed to get sharp action shots, but sometimes too fast a shutter speed will freeze the action and kill all the excitement. For example, the shot of the Volvo has a static appearance because there is little action evident in the photo. The shot of the Volkswagen was made at a much slower shutter speed, and the action is evident in the photo. In both cases, the camera was panned with the car, i.e., the shutter was tripped while the car was being ''tracked'' by the camera.

The sequence of the careening car and the cameramen was shot with a motor-driven Nikon and is a good example of when a fast shutter speed should be used for action work. Here the action is obvious even though each shot is

''frozen'' by the fast shutter speed.

Action photo possibilities occur in all kinds of lighting conditions. The best thing to do is first decide on an appropriate shutter speed, then on an appropriate f-stop to make sure the depth of field covers enough area, then choose the slowest film that will allow you to use this combination.

When in doubt, or to be ready for the unexpected, it is better to use a faster shutter speed than a slower one, because you can create the illusion of motion by moving the enlarging easel when exposing a print from a sharp negative, but you

1. Shutter speed of 1/15 second produced shot that says action.
2. Similar shot, at 1/500 shutter speed, results in static look.

cannot make a blurred image sharp.

NIGHT PHOTOGRAPHY

One of the major problems in night photography is getting separation between buildings and the night sky. The answer to this is to shoot in late sunset, when it's almost night, but there is still a bluish color to the sky. This is a very effective time to shoot in color, too. If you're photographing a well-lit building, then a late-at-night shot would be proper.

Try to do something different with your night shots. Once you have satisfied the rules of good photography and decided on your angle, do something in the picture that says you are a little bit different, that you're a bit more creative than the guy with his box camera. Fog and rain can be used for effect, but make the effect obvious. Fog is best in the distance, or around lights, where you can see it.

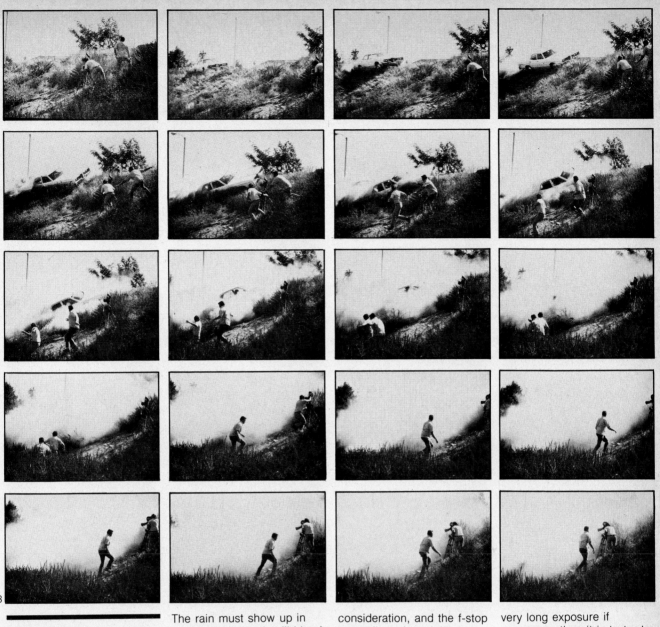

3

3. Although car is "frozen" in action sequence from TV series "Cannon," the action is still evident, so shots work.

The rain must show up in your picture, but it will blend into the scene with too long an exposure. That can be used to advantage in some situations. Consider new angles on blurred traffic pictures. Get in your car and drive a block with your camera on Bulb. But try to do something to record the scene in a slightly different way than it has been done before.

The photo on the inside front cover of this book was a timed exposure with the light meter reading taken at the edge of the hill to get some separation on the horizon. This was my first

consideration, and the f-stop was adjusted to give me enough time to blur the traffic. The shot needs the visible horizon to show the true depth of the traffic; without it, the perception of the distance suffers.

In night scenes, it is better to expose properly, using a

very long exposure if necessary, than it is to try to push your film speed and overdevelop the film. Overdevelopment will only increase contrast and decrease detail. When using long exposure times, you might have to compensate for reciprocity failure, as explained in the chapter on low-light photography. □

Exposure was based upon reading of right side of building, which provided separation between the building and sky. Exposure time sufficiently long to blur traffic was used, with f-stop chosen as per meter reading.

general photography

In this book thus far I have been showing you how to deal with the various available-light situations you can use to advantage for specific types of photography. Now I'll show you some problems and solutions you might encounter in day-to-day photography.

Many of the photos in the rest of this book were shot as examples of what each chapter was explaining. The shots in this chapter were taken before the book was written. While going over them, keep in mind the "system" of available-light photography:

1—Find the lighting you want, or create it by using cardboard reflectors and scrims.

2—Decide if you want more or less contrast than the lighting provides, and mentally adjust your development.

3—Decide if the adjustment in development or the scenic detail make it necessary to over- or underexpose the negative.

4—Develop and print the negative to completely produce the feel you wanted from the original scene. □

The most important thing in this shot is the almost solid black outfit. With the sun behind the model Beverly, I had to overexpose the film to record some of the detail in the black, but could not underdevelop too much for fear of losing the detail. The print was dodged in the black areas to allow more detail to show.

2

1. Clown has enough contrast in form of paint on his face to make normal negative happy, but I was after wrinkles and character, so I overexposed slightly and underdeveloped to record every minute detail. With the resulting slightly flat negative, all I had to do was print for a bit more contrast, and all the character appeared.

2. This is a grab shot, where I was forced to give up detail in the interest of the action. Actor Tim Forsythe was told to cross the intersection and in the middle to break unto an Irish jig. I had to use a fast shutter speed to freeze the action, and was not able to compress the film enough to carry the detail in the lady's white coat and the dancer's robe, but the shot does say what is necessary.

3. Available light with almost even direction forces you to expose normally but overdevelop to force contrast. Otherwise, the shadow and highlight difference is too small to produce a good print.

4. Here's a flat scene containing black walls and dark objects. Exposure should be normal, with contrast added during printing.

5. The only important thing is shot of mechanic is lighting on his face. Normal exposure and development will produce good print, with loss of detail in shadow areas unimportant.

3 4

5

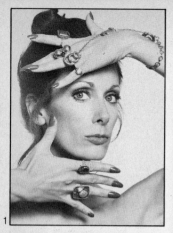

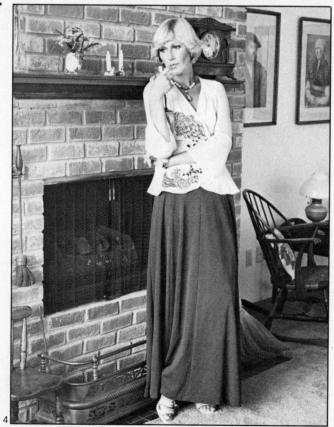

1. The size of the window used to light model Nancy Chadwick was very small (look at its reflection in her eyes), so I had to shoot almost wide open. With very little depth of field, and with the jewelry as the important subject, overexposure or exposure for the background was impossible, so I exposed and developed normally to prevent any loss of detail in the jewelry, then snapped up the print in the darkroom, printing to keep the wall white.

2. Using window light with a white subject containing fine detail rules out overdevelopment, or the detail will be lost. Contrast was added to shot of Debbie DuShane during printing in the darkroom.

3. This simple backlit shot was underdeveloped to prevent losing detail in the tie and hair, and the contrast was added during printing. Model is Kari.

4. With model Beverly Guevarra in large open room having very flat window lighting, the first impulse was to overdevelop the negative to obtain contrast. However, this would have produced too much contrast on white blouse, so contrast was put in during printing process.

5. Direct sun lit Regina Parton for this shot. If I had not compressed the film, the shadows would have been severe. As it was, I overexposed three stops and underdeveloped 30 percent. This produced a straight print, with plenty of shadow detail.

6. This is the shot that inspired the cover. However, this one was done with an overcast, exposed normally and overdeveloped to increase contrast, which was necessary to help separate model Lee Spataru's face from her hands, and to keep the screen light in the dark areas.

6

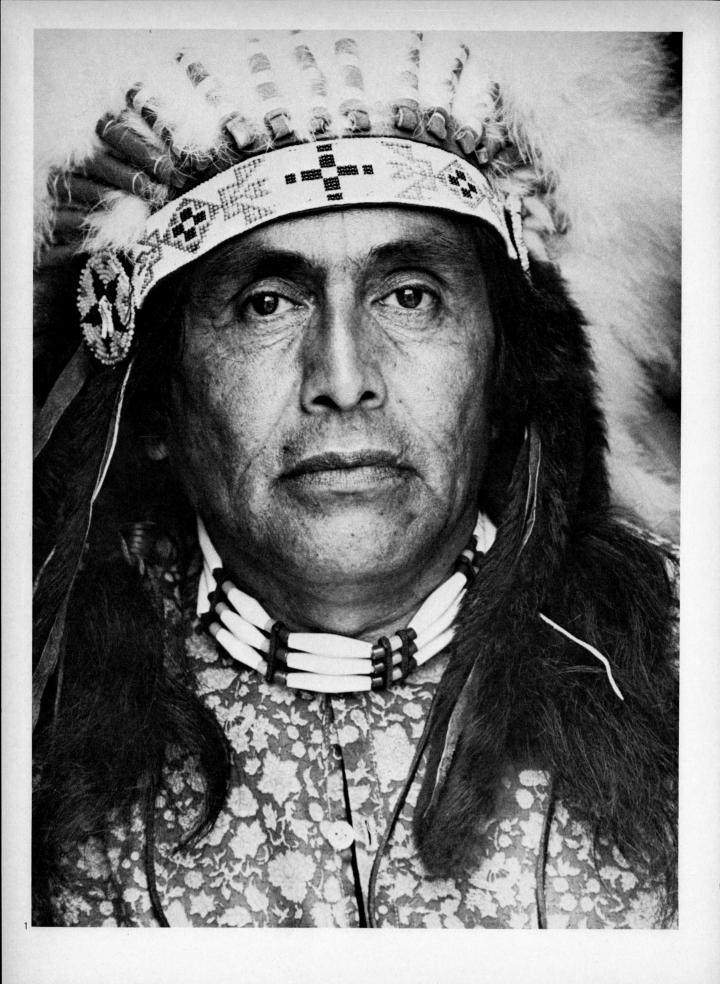

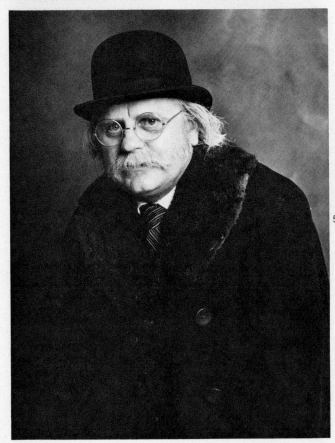

1. Finding the lighting is the secret to this shot. I simply placed actor Frank Salsedo inside the flap of a teepee, and worked from edge to edge of the opening to obtain a direction of lighting. Normal exposure and development were used.

2. Only a slight amount of underdevelopment was used with this direct sunlight shot, to keep rocks in the background from reproducing as a mushy gray.

3. Shot of James Lennon was taken in direct sunlight coming from behind him. By slight overexposure and slight underdevelopment, I kept some detail in his hair, but still lost detail in the right shoulder of his jacket. With most of the subject matter in shadow, the important thing is to have the contrast there, even with the loss of detail on the edges.

4. Shot of Tony Valanas was made using the north light technique, but with a difference. Here I was after the character more than the detail of the coat, and I simply exposed the film normally and overdeveloped slightly to add kick to the face. The addition of a bit of contrast in the print added to the overall effect.

5. Working this close to the window, the necessary thing is to compress the film, although the amount is up to you. Too much can be corrected in the darkroom, but too little will result in too much contrast for a good print.

1. With the vine-covered trellis above the models' heads acting as a natural scrim, a lighting pattern from the front and a kicker from the side produced a simple and soft directional light for this shot of Sandy Borgsmiller and Brian Coverdale. Because the light was flat, slight overdevelopment was necessary, although contrast could also have been added during printing.

2. In a backlit situation like this, with models Brian and Sandy, you should expose for the shadows and add any needed contrast in the printing. This will retain as much detail as you need, but still show the backlighting effect.

Inside back cover: Model Linda Alexander was photographed in a style inspired by the beautiful work of Paine, and his Mirror of Venus. I had her lie down almost directly under a window, and placed the leaves around her. With an extremely soft direction of lighting, as well as almost no major contrast, I overexposed and overdeveloped the negative. This added highlights to the hair that were hardly apparent in the real scene.